Prints of the Floating World

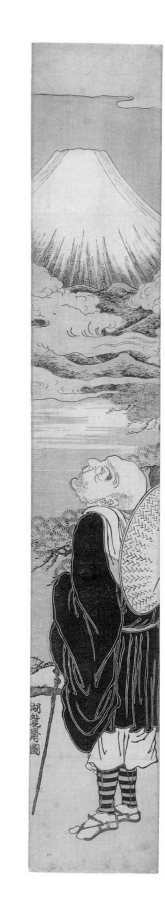

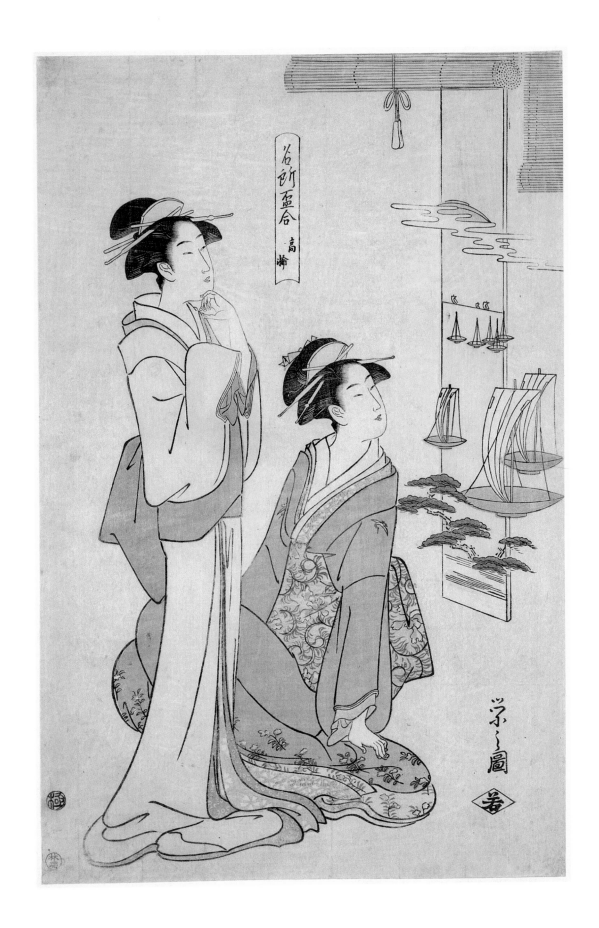

Prints of the Floating World

Japanese Woodcuts from the Fitzwilliam Museum, Cambridge

Craig Hartley

With a contribution by Celia R. Withycombe

The Fitzwilliam Museum, Cambridge
in association with
Lund Humphries Publishers, London

First published in 1997 by
The Fitzwilliam Museum, Cambridge
in association with
Lund Humphries Publishers Ltd
Park House, 1 Russell Gardens
London NW11 9NN

British Library Cataloguing in Publication Data
A catalogue record for this book is available from the British Library

ISBN 0 85331 698 8

Photography by Andrew Morris
Designed by Ray Carpenter
Made and printed in Great Britain by
BAS Printers Limited, Over Wallop, Hampshire

Distributed in the USA by
Antique Collectors' Club
Market Street Industrial Park
Wappingers Falls
NY 12590
USA

Illustration p.1: Isoda Koryūsai (active *c.*1766–88), *Saigyō Hōshi contemplating Mount
Fuji*. Colour print from woodblocks. 1770s. (See Plate 11)

FRONTISPIECE: Hosoda Eishi (1756–1829), *Sails returning at Takanawa
(Takanawa kihan)*. Colour print from woodblocks. Ōban, 374 × 246mm. From the
series *Famous places represented as sake cups (Meisho sakazuki-awase)* published by
Wakasaya Yoichi. 1795. Given by T. H. Riches 1913

CONTENTS

This publication was made possible through the
generous support of Toshiba International Foundation

FOREWORD

Ukiyo-e (pictures of the floating world) produced by Japanese artists, publishers and craftsmen of the Edo period (1603-1868), constitute one of the most remarkable and spectacular achievements in the history of graphic art. This book traces the historical, stylistic and technical development of these prints, from the early hand-coloured work of the seventeenth century to the spectacular colour printing of the mid-nineteenth century; with a postlude giving us a glimpse of printmaking in the succeeding Meiji period. In his introduction, Craig Hartley explains the historical context of the 'floating world' culture that is depicted in many of the prints and expressed in their style and treatment of subject-matter. Celia Withycombe, in her essay, provides an insight into the technical refinement of Japanese woodblock printmaking. The main body of the book consists of a survey of over seventy prints with detailed texts explaining their significance.

All the prints illustrated in the book are drawn from the collection of the Fitzwilliam Museum in Cambridge, which started collecting *ukiyo-e* as long ago as 1896, the year after the last print in this book was made. Many prints are reproduced here for the first time. Although the selection has been made to allow the reader access to a wide range of artists and subjects, it also reveals the particular qualities of the Fitzwilliam's collection: most notably the fine landscapes by Hokusai and Hiroshige, and the unique set of *Chūshingura* prints by Utamaro formerly in the collection of Edmond de Goncourt. (The Fitzwilliam also possesses a large collection of *surimono* – privately commissioned and distributed prints – which it is hoped will be the subject of a separate publication in the future.) The character of the collection was shaped by the tastes of Western private collectors in the first half of this century, whose generous gifts and bequests have been the main source of the Fitzwilliam's prints. Principal among these were the gift of over 160 prints from Thomas Henry Riches in 1913, the Oscar Raphael Bequest received in 1946, the Henry Scipio Reitlinger Bequest received in 1991, and gifts from the Friends of the Fitzwilliam over many years.

The publication of this book would not have been possible without the generous and enlightened support of Toshiba International Foundation to whom I would like to extend the profound gratitude of the Fitzwilliam Museum. I am sure our sense of indebtedness will be shared by all those who cherish Japanese art and culture. Many others who have contributed to the project are named in Craig Hartley's acknowledgements. Here I would like to identify him as the principal author and prime mover of this project and to thank him, along with Celia Withycombe for her valuable contribution, Andrew Morris, the Museum's Chief Photographer, and all those others at the Fitzwilliam Museum. Finally, our thanks go to John Taylor and his colleagues at Lund Humphries Publishers and to BAS Printers for the production and distribution of this handsome volume.

Duncan Robinson
Director, The Fitzwilliam Museum

The floating world

... Living only for the moment, turning our full attention to the pleasures of the moon, the snow, the cherry blossoms and the maple leaves; singing songs, drinking wine, diverting ourselves in just floating, floating; caring not a whit for the pauperism staring us in the face, refusing to be disheartened, like a gourd floating along with the river current: this is what we call the *floating world* ...

Asai Ryōi, *Ukiyo monogatari* (Tale of the floating world), *c.*1661[1]

THE PRINTS in this book belong to the tradition known as *ukiyo-e* (pictures of the floating world).[2] The word 'floating world' (*ukiyo*) comes from a Buddhist term originally describing the present sorrowful world of pain, in contrast to the heavenly world of paradise. In the second half of the seventeenth century the usage of the word shifted. Instead of being written with the character meaning 'sad world' it was written with the character for 'floating world' and its meaning moved from one of pessimism about the everyday world to one of optimism, even hedonism, about the pleasurable world of the here-and-now. The classic definition of *ukiyo* quoted above stands at the beginning of the extraordinary 'floating world' culture that developed and flourished in the Edo period (1603–1868) under the military dictatorship of the Tokugawa *shōgun*. This culture was expressed in the lifestyle of the leading players in the floating world, and it survives in the vivid imprint of their ephemeral existence: in the poems, novels, plays, paintings and prints that they left behind.

It was the woodblock printing industry, with its technical facility to combine text and image, that gave the floating world its cohesion and spread its influence. New forms and formats thrived on the popularity of the floating world as a subject. Some of them – such as *ukiyo-zōshi* (stories of the floating world) – faded as new fashions emerged; others – such as *ukiyo-e* – survived as a style even after the floating world had passed into history. In addition, older forms of literature evolved a more playful and up-to-date character as writers adapted to the style and subject-matter of the fashionable floating world. The most obviously popular medium of the period – *kabuki* theatre – developed along with the concept of *ukiyo*. As with all floating-world art, its subjects revolved to a large extent around the Yoshiwara, the licensed pleasure quarter in Edo (present-day Tokyo). *Ukiyo-e* artists and publishers were able to exploit the phenomenal public fascination with leading *kabuki* actors and the near-legendary courtesans of the Yoshiwara, and in doing so they contributed to their popularity. The *ukiyo-e* print developed into a mass-produced popular art intended to reach a wide audience.[3] Yet its lasting success also depended on technical finesse, and on subtle visual and literary references that enabled artists to cloak modern subjects in the rich fabric of Japan's legendary and poetic past. We shall return to these qualities after examining the world in which *ukiyo-e* flourished.

The rule of the *shōgun*

'Floating-world' culture arose out of the specific social climate that developed in the city of Edo under the rule of the *shōgun*, and its character is best understood in the context of that society.

After a century of raging civil war between the feudal lords (*daimyō*) who led the various clans of the military aristocracy (*samurai*), the Tokugawa clan gained the upper hand at the battle of Sekigahara in 1600 and Tokugawa Ieyasu assumed control as the first *shōgun*. By 1603 the basic relationship between emperor, *shōgun* and *daimyō* was defined as it would survive essentially unchanged for the next 250 years. The emperor remained as a figurehead with his court in Kyoto, the imperial capital since 794. He conferred on Ieyasu Tokugawa the title *seii taishōgun* ('barbarian-subduing generalissimo') – or *shōgun*. Ieyasu quickly moved to establish the title as hereditary, building his castle and seat of government (*bakufu*) in Edo in the east, where he and his descendants ruled until the restoration of power to the Meiji emperor in 1868. The *daimyō* remained in charge of their regional domains (*han*), each with a ret-

inue of *samurai* upon whom the *shōgun* could call as an army. To maintain their allegiance and subdue any threat to his position as ruler, the *shōgun* maintained a strict hierarchical society and imposed fiscal, social and foreign policies that would tend to weaken the hand of the *daimyō* and strengthen his own position in Edo.

Successive governments pursued an isolationist policy that restricted foreign trade and travel, thus limiting the 'dangerous' influence of alien philosophies and religions, particularly Christianity. By the 1640s only a limited amount of trade was allowed with the Chinese and the Dutch via Dejima, an artificial islet constructed at Nagasaki on the west coast of Kyūshū, the most southerly of Japan's main islands. This also allowed the government to restrict the import of foreign books, appointing official interpreters at Dejima to filter them. Only 'useful' European ideas – called 'Dutch learning' (*rangaku*) – were tolerated from time to time, principally concerning medicine or astronomy. This closed-country policy (*sakoku*) was maintained until the 1850s, when foreign demands that Japan should open up to commerce were backed by military threat and finally forced a reversal of the policy, with consequences leading to the fall of the Tokugawa regime and the subsequent transformation of Japanese society.

The hierarchical structure of Edo society was based upon Confucian principles, particularly those formulated by Chinese scholars in the Song dynasty in accordance with the harmony that they perceived in the hierarchical structure of the natural world. Japanese scholars and rulers adapted these philosophies to the situation in Japan, grafting them onto native beliefs such as Shintō religion ('the way of the gods'). Hayashi Razan (1583–1657), the Japanese scholar who founded the government-sanctioned Confucian school in Edo in 1630, explained:

> The five relationships governing ruler and subject, father and son, husband and wife, older and younger brother, and friend and friend, have been in existence from olden days to the present. There has been no change in these basic relations, and they are thus called the supreme way . . .
>
> Heaven is above and earth is below . . . In everything there is an order separating those above and those below . . ., we cannot allow disorder in the relations between ruler and subject, between those above and those below. The separation into four classes of *samurai*, farmers, artisans and merchants, like the five relationships, is part of the principles of heaven and is the Way taught by the Sage [Confucius].[4]

This scale of four descending classes – *samurai*, farmers, artisans and merchants – was justified on the basis of the individual's perceived usefulness in an agrarian society. *Samurai*, the hereditary elite, were those educated in 'the arts of peace and war' (*bun* and *bu*) deemed necessary for wise and strong leadership. Farmers produced the basic food that allowed people to live. Artisans were next in the chain, turning raw materials into useful products. Merchants were placed at the bottom of society because they did not create anything of practical use and were thought merely to profit from the productiveness of others.

The stable society maintained under Tokugawa rule enabled the growth of the leisured pursuit of the arts in Edo that led to the development of the floating world. Yet while the *shōgun* made moves to impose this hierarchical structure throughout the Edo period, there was a tension between on the one hand, a system based on an agrarian economy and military might, and on the other, the growth of an urban economy increasingly dominated by the opulent tastes and purchasing power of the merchant or townsman (*chōnin*). Hierarchical distinctions in society became most fluid in the melting-pot of Edo itself, and particularly in floating-world society and culture. In essence, the pleasures of the floating world offered an alternative existence, a world of escape from the straitjacket of hierarchy, duty and status.

The growth of Edo

Before the establishment of Tokugawa rule, Edo was a mere village of some 200 inhabitants, situated in the Kantō plain where the Sumida River enters Edo (now Tokyo) Bay. By 1605 it was a castle town of 5000 dwellings. The population grew to 150,000 by 1610, and numbered more than 500,000 by 1657. By 1720 Edo was one of the largest cities in the world with well over a million inhabitants. Over half of these were *samurai* whose vast presence in the city was mainly due to *sankin kōtai* (alternate attendance), an edict of 1630 that required *daimyō* to spend six or twelve months of every alternate year in Edo. Furthermore, they were required to leave their wives and family in Edo as hostages when they returned to their regional domains. In Edo each *daimyō* had to maintain three estates: a mansion in the city for himself and domain business, a mansion for the permanent residence of his family, and a suburban retreat in case of one of the fires that swept the tinderbox city every six years or so. Part of his retinue of *samurai* would accompany the *daimyō* back and forth to Edo; the rest would remain in the city.

This growing concentration of the population in Edo had two significant effects. Firstly, it resulted in 'culture's march eastward' from the refined court world of letters and traditional schools of painting practised in Kyoto. Secondly, it resulted in a burgeoning class of wealthy tradesmen and merchants emerging among the *chōnin*, who serviced the needs of the growing city.

Samurai remaining in Edo, or those there on *sankin kōtai* duty, were left with little to show for their former military prowess, besides the privilege of wearing two swords in public. They had time on their hands to entertain themselves, dabble in literary pursuits and spend money. As time went on the townsmen became rich, usu-

ally at the expense of *samurai*, who borrowed money against their rice allowances. Class distinctions became blurred. Increasingly impoverished *samurai* were obliged to make money by adopting a profession or trade; increasingly wealthy and well-educated *chōnin* were able to indulge in tastes and habits that previously only came with the privilege of hereditary status. *Chōnin* and *samurai* alike aspired to be *tsū* (witty and urbane sophisticates) in their pursuit of *iki* (sophisticated style). Wealthy *chōnin* became the trendsetters and Edo a place of urban chic manifested in the fashions and art of the floating world. And this culture was so firmly identified with vibrant Edo society that *ukiyo-e* prints became known as *Edo-e* (Edo pictures).

The pretensions of would-be *tsū* were described and satirised in the new genres of *gesaku* (playful) literature developed in the second half of the eighteenth century. Here is a description of the scene at Ryōgoku Bridge from a humorous tale published in 1763:

> Where there are priests, there are laymen, and where there are men there are women. For every countrified *samurai* there is a stylish townsman wearing a long comb and a short *haori* (jacket). The young master's attendant carries along a goldfish in a glass bowl; the noblewoman's followers dangle pipe cases of gold brocade; the buxom maid-in-waiting hauls her buttocks along; the overweening bodyguard-for-hire, rather than wearing his two swords, seems himself to be an appendage to them.[5]

The area around Ryōgoku Bridge was one of the main entertainment areas in Edo, and a frequent site of street carnivals (*misemono*), when all layers of society congregated to see the latest novelties and spectacles. Here is a description of the scene at Ryōgoku a century later:

> . . . the 'three sisters' female *kabuki*, peep-shows of Chūshingura, *Naniwa-bushi* chanting . . . beggar's opera (*deroren*) . . . raconteurs, archery booths, barbershops, massage healers, and around them peddlers of toys, loquat leaf broth, chilled water, . . . confectionery, . . . chilled and solidified agar-agar jelly, *sushi*, . . . tempura, dumplings, stuffed Inari fritters, fried eel livers, insects, lanterns, as well as wandering masseurs and Shinnai balladeers, peddlers of all sorts, blowgun booths, . . . fortune-sellers with lanterns dangling from their collars, vendors of 'streetwalker' noodles, drunks, quarrels, pests, public urination.[6]

The growing spread of popular culture was not restricted to the streets. By the beginning of the nineteenth century printed books reached a wider audience as a result of the government policy of public education (intended to spread orthodox thought) and the introduction of lending libraries (*kashihonya*). Native *Edokko* ('children of Edo') could read about adventures in 'The bathhouse of the floating world' (*Ukiyo-buro*, 1809) or 'The barbershop of the floating world' (*Ukiyo-doko*, 1814). Floating-world culture broadened and permeated the city, and its spirit was carried out into the country by travellers along the major highways (see Plates 42-5).

Yoshiwara

The Yoshiwara licensed pleasure quarter was the hub of the floating world. It was set apart from Tokugawa society by its location, language and code of behaviour; a world where one man's money was as good as another's, and privilege could be bought, albeit at fantastic expense.

In order to control nightlife and prostitution, which were considered likely sources of urban disorder, each major town compelled brothel owners to restrict their businesses within a licensed quarter (*yūkaku*). In 1617 the *bakufu* in Edo designated the Yoshiwara, a newly formed neighbourhood near the administrative centre of the city. In 1629 a comparable area, Shinmachi, was defined in Osaka, and in 1641 Shimabara was designated in Kyoto. A great fire in Edo in 1657 destroyed the old Yoshiwara, and the licensed quarter was subsequently relocated to the area beyond Asakusa Temple on the northern edge of the city. The new area was called *Shin* (New) *Yoshiwara*, although the older name persisted. It consisted of twenty acres of land surrounded by a moat and high walls, with a single gate that was manned by guards and closed at night.

The Yoshiwara is visible in Hokkei's print of the 1820s (Fig.1), where it can just be seen at the top left of the city beyond Asakusa Temple. Visitors would normally approach it in one of two ways. Either they would walk up through the precincts of Asakusa Temple, or they would travel by the more pleasurable (and expensive) means of a boat up the Sumida River. Water-taxis (*chokibune*) were normally hired at Yanagi Bridge near Ryōgoku; the bridge and boats on the river can be seen in Plate 56. The boats would take the customer as far as the entrance to the Sanya Canal, which is seen in Plate 58 and just glimpsed through the cloud of mist along the edge of the river in Fig.1. Here the visitor would alight and walk the final stretch along the Nihon embankment; we see tiny figures making their way along the embankment in Fig.1. Arriving at the Yoshiwara, the visitor entered through the great gate, which opened on to the main thoroughfare, Nakanochō. This street was lined with assignation tea-houses (*hikite-jaya*), which arranged appointments with courtesans in the leading brothels situated in the complex of streets either side of the Nakanochō. In the early evening glamorous high-ranking courtesans (*oiran*) promenaded on the Nakanochō in their spectacular regalia, with their apprentices (*shinzō*) and child-attendants (*kamuro*).

The confined society within the Yoshiwara walls may have been like a sort of prison to the courtesan and her assistants while they served out their terms of contract, but to the wealthy *chōnin* or mortgaged *samurai* it was a place of escape, a world of dreams made

東都金龍山淺草寺圖

FIG. 1 Totoya Hokkei (1780-1850), *Picture of Kinryūzan Sensō-ji Temple in the Eastern Capital* (*Tōto Kinryūzan Sensō-ji zu*). Colour print from woodblocks. *Ōban*, 448 × 633mm. 1820s. H. S. Reitlinger Bequest 1991 (P.620-1991)
A dawn view of Asakusa Temple in Edo looking north to Mount Tsukuba, with Azuma Bridge crossing the Sumida River on the right.

tangible. Its delights were mapped out in the Yoshiwara guidebooks (*Yoshiwara saiken*), and celebrated in floating-world prints, literature and drama. The extent to which *ukiyo-e* prints helped to glamorise the Yoshiwara in the eyes of the public, presenting leading courtesans as modern equivalents of the refined courtly and literary heroines of the past, can be seen in Plates 21-7. This glamorous image was not mere artistic licence, however, but part of an effort by the brothels of the Yoshiwara to set themselves apart from the many unlicensed brothel districts (*okabasho*), which had few cultivated

trappings. Life for the Yoshiwara courtesans could be equally sordid and harsh, particularly if they fell ill, but brothel owners did everything they could to enhance their aura of exclusivity. *Oiran* were provided with fabulous costumes, taught calligraphy by leading masters of Chinese seal-script, and instructed in the delicate art of the tea ceremony. They even had their own language (*arinsu kotoba*), which had developed from the dialect of the Kyoto licensed quarters. *Oiran* played no part in the financial transaction and were entitled to refuse clients. In turn, clients were expected to observe elaborate etiquette in engaging their services. The women were to be treated as though they were princesses, and that is how they usually appeared in prints. Together with stars of *kabuki*, the *oiran* became cultural icons of the floating world, and as with actors, their near-legendary names were passed on from one generation to another.

Kabuki

The origins and development of *kabuki* theatre were also linked to attempts to regulate prostitution. In 1603 a troupe of itinerant female entertainers led by a woman called Okuni came to Kyoto and performed what purported to be dances from Izumo Shrine, but were actually suggestive folk dances. The performers were evidently prostitutes, and their performances served as a preliminary to entice young *samurai* backstage for more intimate entertainment. Other troupes of women performers known as *onna kabuki* appeared with more elaborate stage productions of song and dialogue, but these were also fronts for prostitution, and in 1629 the *bakufu* banned female actors from the stage. Their place was taken for a while by adolescent boys in *wakashū kabuki* ('youth's *kabuki*'), but these proved to be male prostitutes, and so from 1659 only adult males were allowed to perform.

Kabuki subsequently developed into a more elaborate stage spectacle with complex plots and productions, and specialist professional actors. Edo became the major centre of *kabuki*, although there were also thriving theatres in Kyoto and Osaka. The three main Edo theatres were the Nakamura-za, the Morita-za and the Ichimura-za. Each was surrounded by a cluster of tea-houses (*shibai-jaya*), which could reserve boxes for wealthy theatre-goers and provided refreshment between acts. Performances continued all day, with some acts serving as comic or dance interludes. By the eighteenth century, plots usually involved the Yoshiwara. Even when the story was a historical subject derived from the puppet theatre or from the corpus of Muromachi-period *nō* plays, it was usually laced with an amorous subplot, frequently set in the Yoshiwara. The restriction on women performers meant that female roles, often intended to represent the most beautiful courtesans, had to be taken by male actors (see Plates 3 and 5). These were frequently specialists who took their female impersonations so seriously that they continued to wear women's costume in their lives outside the theatre. Like the leading male-role actors the female impersonators (*onnagata*) became superstars, and they even set trends in female fashion and influenced the way women behaved in society. Unlike the Yoshiwara, *kabuki* theatres were not merely the preserve of male visitors, and women were among the most enthusiastic *kabuki* fans (a lady of *samurai* class can be seen looking at an actor print in Fig.2). Leading actors such as Segawa Kikunojō II (Plate 5) and Danjūrō v (Plates 6 and 8) had massive fan clubs and supplemented their huge earnings by endorsing products with their names. They were also prominent figures in the floating world. Tea-houses and restaurants played host to parties and literary gatherings of actors, writers and *ukiyo-e* artists.

Kabuki derived some of its elements from *nō* drama, including dance, stylised posture and aspects of staging such as the *michiyuki*, or 'poetic journey' (see Plate 27, Act 8). Most plays were structured around critical dramatic moments in which the action would freeze and actors would strike and hold forceful poses and expressions (*mie*). These frozen moments were ideally suited to be captured by artists in *ukiyo-e* prints, which were often published to advertise or coincide with particular performances. Actor prints were just one part of the avalanche of printed publicity, programme books and souvenirs surrounding productions at the major theatres, and the artists who specialised in actor prints also produced designs for the other printed material (see Plates 3–9).

Censorship and regulation

Despite the mixing of classes in the floating world, the hierarchical distinctions remained embedded in society at large, and were periodically reinforced by a government keen to police *samurai* lapses or *chōnin* pretension, whether these occurred in print, or in society.

In 1842 the *bakufu* banished the actor Danjūrō VII from Edo as a punishment for his luxurious lifestyle. This was only the latest result of a series of decrees, known as sumptuary regulations, intended to reinforce the Confucian idea of status by keeping displays of luxury at a level appropriate to the rank of the person in question. Similar decrees were issued in an attempt to moderate the content of books and prints, purportedly to protect public morals, but also to quell any incitement to dissent.

Sumptuary regulations, aimed mainly at *chōnin* in cities, covered a whole range of subjects, including the amount and type of decoration on clothing, the types and amounts of food to be eaten, the size of buildings, construction materials, the scale of entertainments such as weddings, the materials and decoration of women's combs and bodkins, tobacco pouches, purses, incense containers, lacquer *sake*-cup-stands and cake-boxes, and the size and costume of dolls.[7] Such rules were frequently flouted, and few people were punished except when the magistrates decided to make an example of someone famous like Danjūrō VII. This only usually occurred at times of economic crisis, and potential or actual public unrest, resulting in sudden flurries of regulation and enforcement. Three such periods of reform were of direct influence on *ukiyo-e* prints.

The Kyōhō reforms took place under the *shōgun* Yoshimune (1678–1751) in a series of edicts issued by the Edo city magistrate Ōoka Tadasuke in 1721 and 1722. The main strictures were as follows: new works could only be printed or imported from other cities with the approval of the city magistrate's office; 'unusual' works and erotica were to be phased out of production; the printing and selling of baseless stories, rumours, and fallacious or unorthodox theories were forbidden; current events could not be depicted in single-sheet prints; nothing concerning other people's ancestral lineages could be printed; the Tokugawa family could only be mentioned with special permission; each book or print had to include the names of the publisher and the author or artist. The

FIG. 2 Utagawa Toyokuni (1769-1825), *Picture book of up-to-date fashions (Ehon imayō sugata)*. Colour prints from woodblocks. Published by Izumiya Ichibei, Edo, 1802. Given by T. H. Riches 1913

This page shows the fashionable amusements of women in a *samurai* household. The woman in the right foreground is looking at prints of actors and courtesans.

initial inspection of books and prints was to be carried out by publishers' associations and only difficult cases reported to the magistrate's office.[8]

Most limiting for *ukiyo-e*, and also for *kabuki* theatre, was the ban on 'current' events. It was for this reason that although the play *Kanedehon chūshingura* (see Plate 27) was based on a historical inci- dent of 1702-3, the action was moved back into the fourteenth cen- tury (*ukiyo-e* did not openly portray contemporary events until the 1870s, see Fig. 5). The 1722 ban on erotica (*shunga*) failed to stop the printing of this category of *ukiyo-e* (see Plate 15), which was subse- quently issued privately or sold under the counter. Nor did anoth- er restriction, limiting the publication of calendar prints (*egoyomi*) to eleven official publishers, stop a group of literati privately commis- sioning luxuriously printed *egoyomi* from Harunobu in 1765. These were the first multicolour prints, known as *nishiki-e* ('brocade pic- tures'), and their subsequent commercial production might have come under sumptuary scrutiny if the 1760s had not fallen within

the lax regime of the grand chamberlain (*sobayōnin*) Tanuma Oki-tsuga (1719-88).

The next major series of regulations took place after the Tem-mei famine of the 1780s, which was partly caused by the eruption of Mount Asama in 1783. The subsequent Kansei reforms of Mat-sudaira Sadanobu (1758-1829), chief councillor of the *bakufu*, result-ed in several edicts issued in 1790 repeating many of the ineffective earlier regulations, including the phasing out of erotica (*shunga*). There were three significant additions. Firstly, the new lending libraries (*kashihonya*) and wholesalers (*serihonya*) were also to come under inspection. Secondly, for the first time publishers of prints and picture-books were required to appoint representatives (*gyōji*) to act as censors; the new censors' seal of approval (*kiwame*) therefore began to appear on prints from this date. Thirdly, the edicts banned satirical comic-strip novelettes called *kibyōshi* (yellow covers), which had been all the rage in the 1780s among artist-writers such as Santō Kyōden (Masanobu, see Plate 23). When Kyōden and his publisher Tsutaya Jūzaburō offended again in 1791, the writer was sentenced to fifty days in handcuffs, the publisher was fined half his net worth, and the censors who had approved the publications were banished from Edo.

A specific limitation for printmakers such as Utamaro was the edict of 1793, reinforced in 1796, banning the appearance on prints of names of women other than courtesans (see Plate 27). But per-haps the most remarkable artistic ban was that of 1800 prohibiting 'prints with large faces of women' because they were too 'conspic-uous' (see Plate 26). Utamaro did in fact fall foul of the authorities for a different reason in 1804, when with Toyokuni and several other artists he was put in handcuffs for designing prints that depicted and named illustrious warriors from the *samurai* clans overthrown by Tokugawa Ieyasu in the 1590s.

The final set of edicts appeared after the Tempō famine in 1842, the year that Danjūrō VII was banished from Edo. Censorship was reorganised, and taken out of the hands of the publishers' associa-tions until 1851. New regulations were stringent. They banned depictions of *kabuki* actors, prostitutes and *geisha*; outlawed colour printing for book-covers; restricted the number of colour blocks to be used in a single print to seven or eight; and limited the price of prints to sixteen *mon* in order to restrict their luxury. By 1850, most of these regulations were relaxed and Danjūrō VII returned to Edo. Meanwhile, *ukiyo-e* print designers, particularly Kuniyoshi, devised virtuoso ways of getting round the laws, portraying *kabuki* plays in the guise of warrior-prints, and famous actors' faces on goldfish, tur-tles and characters from folk-paintings (see Plate 53).

Poetry and allusion

Utamaro's series of prints relating to the *kabuki* play *Kanadehon*

chūshingura (Plate 27), recasts the conspiracies and skirmishes of the *samurai* as the foibles and squabbles of contemporary tea-house waitresses and courtesans. This is an example of *mitate*, a term mean-ing 'likened', but as used to describe prints the sense is closer to 'par-ody'. Fashionable or 'up-to-date' (*fūryū*) versions of historical, legendary or poetic originals were common in *ukiyo-e*, and their playful, mocking character is typical of floating-world culture as a whole. Another series by Utamaro shows the life of the Heian-period poet Ono no Komachi brought 'up to date' in the Yoshi-wara (Plate 26). It pokes fun at tradition while bringing a resonance of the Heian court to the modern world of the courtesan.

The ability of *ukiyo-e* to encompass several readings of the same scene, as though they are floating in layers, depends on the richness of visual and literary allusion in the wider traditions of Japanese art and literature. This allusive quality is a corollary of the ambiguity of the Japanese language, with its extraordinary potential for elaborate wordplay. The prints in this book provide many instances of artists playing various games of allusion. Visual allusions range from poses of lovers in a brothel that bring to mind a scene from the annals of military history (Plate 16), to emblems on clothes referring to chap-ters in the courtly classic, *Genji monogatari* (The tale of Genji; Plates 16, 22 and 24). Literary allusions could also be easily accommodat-ed in woodblock prints as text, and there are many examples of poems that expand or deepen the meaning of an image, or poems whose meaning is itself expanded by what is depicted. This interplay is hardly surprising in a culture where written language was closely derived from pictograms. Indeed, in one set of prints by Hokusai the outlines of poets are actually drawn in the shape of the Chinese characters for their names (Plates 32-3). Many poets were artists and *vice versa*; they might inscribe their poems calligraphically and paint them in pictures on the same scroll. This literary dimension is strongly present in Harunobu's prints, where the meanings of poem and image float together on the paper (Plate 12). We see this in a dif-ferent form in Hokusai's set of landscape prints depicting poems from the thirteenth-century anthology that was used to play a poem-matching card game at New Year (Plates 38-40). Poetry clubs commissioned albums and *surimono* (see Fig.4) as vehicles for their light verse (*kyōka*), with the images and poems playing visual and lit-erary puns on the page. In many *ukiyo-e* the actual calligraphy of the poem is enmeshed in the subject of the print (Plates 23-4). In oth-ers, the mere title of the series, such as Hokusai's 'Thirty-six views of Mount Fuji' (Plates 34-5), might recall a revered grouping of poems or poets – in this case the *sanjū-rokkasen* (thirty-six poetic sages).

The evocative power of specific place names is a strong element of Japanese poetry. Many place names, known as *utamakura* (poetic pillows), evoke specific associations by their very mention. So Hokusai's print of Mount Yoshino (Plate 37) not only recalls the episode of the twelfth-century general mentioned in its title, but also brings to mind the blossom of the mountain cherry (*yamaza-*

kura) for which Yoshino was famous (it is mentioned in a poem inscribed on Masanobu's print in Plate 24). Even though no blossom is evident in Hokusai's view, the association of the place would suggest to the viewer the season of spring, when parties made the pilgrimage to Mount Yoshino to view the cherry blossom. In other cases the associations of a place might recall a specific poem, such as the *hokku* by Matsuo Bashō (1644-94) about the plum blossom at Mariko (Plate 44).

A perusal of five prints in this book, each based to some extent on the traditional set of Chinese painting subjects, 'Eight views on the Xiao and Xiang Rivers', shows how involved this game of allusion could become. The eight Chinese views had been recast by the end of the fifteenth century as eight Japanese views of Lake Biwa in Ōmi Province (*Ōmi hakkei*); Japanese artists who painted the Lake Biwa set intended it to carry an association of the Chinese original. Hiroshige's print *Yabase kihan* (Returning sails at Yabase) is from a set of *Ōmi hakkei*, with the traditional poem associated with the scene inscribed in the cartouche at the top (Plate 47). In the eighteenth century, a number of *ukiyo-e* artists reinterpreted the set of 'eight views' (*hakkei*). Harunobu, for instance, created a set of 'Eight parlour views' (*Zashiki hakkei*), which represented the traditional titles in domestic scenes such as 'Returning sails of the towel rack'. A variation on this is seen in Kiyonaga's print *Risshū no kihan* (Returning boats at the beginning of autumn; Plate 19), which comes from a set entitled *Shiki hakkei* (Eight views of the four seasons). The print shows two *geisha* stepping onto a ferry boat in Edo: a contemporary scene with a double-layered association of both the Lake Biwa and the original Chinese view. In contrast, Kunisada's print (Plate 55) from the series *Soga hakkei jihitsu kagami* (Eight views of the Soga reflected), retains no visual or contextual allusion to the original, apart from the title of *hakkei* (eight views).

Perhaps the most intriguing 'eight views' game of allusion is played out in the print by Eishi reproduced as the frontispiece to this book. Here again we find the equivalent title to 'Returning sails at Yabase' in the Lake Biwa set, but this time the view is from a series showing famous places in the Edo area – *Takanawa kihan* (Returning sails at Takanawa). Many artists played this trick, and as time went on areas other than Lake Biwa acquired a standard set of 'eight views', such as the 'eight views of Kanazawa' depicted in Hiroshige's triptych (Plate 49). But Eishi's print is playing a far more elaborate floating-world game, as we can tell from the series title: *Meisho sakazuki-awase* (Famous places represented as *sake* cups). This is another *mitate* that toys with a venerable tradition in terms of everyday objects. Two women are looking at a painted scroll showing the sea at Shinagawa seen from Takanawa, with the sailing boats that denote the 'returning sails' of the traditional set constructed out of *sake* cups with sails attached. The artist invites us to play with his daring visual conceit in much the same way that a poet might manipulate imagery and metaphor. We find a similar effect in the apocryphal story of Bashō's pupil, Enomoto Kikaku (1661-1707), who was inspired one day by dancing dragonflies to write the following verse:

Red dragonflies!
Take off their wings –
and they are pepper pods!

'No', said Bashō, 'that is not *hokku*. If you wish to make a *hokku* on the subject, you must say:

Red pepper pods!
Add wings to them –
and they are dragonflies!'

This is the visual equivalent of wordplay. Identities become fluid, and as in so many *ukiyo-e* prints, the floating world takes precedence over reality.

NOTES

1. Translated in R. Lane, *Images from the floating world: the Japanese print*, Fribourg, 1978, p.11.

2. Although the term *ukiyo-e* is often used to mean 'Japanese woodblock prints', it actually also encompasses paintings made in the same tradition, often by the same artists who designed the prints. See T. Clark, *Ukiyo-e paintings in the British Museum*, London, 1992.

3. Commercially published prints were relatively cheap. For most of the first half of the nineteenth century an *ōban* print cost about the same as a haircut or an inexpensive meal (twenty *mon*), and about half as much as the cheapest ticket to *kabuki*. There may have been more expensive 'luxury' editions. See E. Tinios, *Mirror of the stage: the actor prints of Kunisada*, Leeds, 1996, p.11.

4. Quoted with slight grammatical alterations from C. Totman, *Early modern Japan*, Berkeley, 1993, p.171.

5. From *Nenashigusa* by Hiraga Gennai (1726-79), quoted by H. D. Smith II, 'The Floating world in its Edo locale 1750-1850' in D. Jenkins (ed.), *The floating world revisited*, Honolulu, 1993, p.33.

6. Andrew L. Markus, 'The carnival of Edo: *misemono* spectacles from contemporary accounts', *Harvard Journal of Asiatic Studies*, vol.45, 1985, p.509.

7. D. H. Shively, 'Sumptuary regulation and status in early Tokugawa Japan', *Harvard Journal of Asiatic Studies*, vol.25, 1964-5, pp.126-35.

8. The material on censorship is based on S. E. Thompson, 'The politics of Japanese prints' in S. E. Thompson and H. D. Harutoonian, *Undercurrents in the floating world: censorship and Japanese prints*, New York, 1991.

The production of *ukiyo-e* prints

Celia R. Withycombe

THE PRODUCTION of an *ukiyo-e* print was a complex process involving whole teams of people, each contributing different skills to the final result. It was reliant upon an independent publisher who played a vital role in overseeing the entire project (whether a single print or a series on a related theme). The publisher was responsible for co-ordinating the production, first by commissioning an artist to make a design, and then by liaising with the different craftsmen who undertook the block-cutting and printing; finally it was he who handled the distribution and sale of the finished prints. His skill in selecting appropriate material for publication and his ability in co-ordinating the different studios was reflected in his success as a publisher. In general, the publisher was recognised along with the artist in having his name printed on the print, whilst the block-carvers and printers, whose names only occasionally appeared on privately published prints, usually went unrecorded until the middle of the nineteenth century (Plates 53 and 55-7).

The first prints in the *ukiyo-e* tradition produced in the second half of the seventeenth century were simple, monochromatic illustrations or *sumizuri-e*, printed in black ink (*sumi*). They were followed by hand-coloured prints, the first of which were known as *tan-e* after the red-lead pigment that was most frequently used. Around 1720 the first *beni-e* (rose-red pictures) were produced. They were named after the delicate pigment *beni* that was used, often in conjunction with green and sometimes yellow. In some instances a glossy effect was achieved by adding *nikawa* (animal glue) to the *sumi* or other pigments (Plate 3 shows *nikawa* applied to the red pigment); the resulting prints were known as *urushi-e*, or 'lacquer' pictures. These changes marked an exciting step forward, but not only did the colouring vary from print to print, it also slowed the production rate and hence increased the cost. The exact date for the introduction of colour into the print process itself is unclear although by the 1740s a number of coloured prints were being produced using the limited palette of the hand-coloured *beni-e*, and were therefore known as *benizuri-e*, or 'printed *beni-e*' (Plate 4). The next significant step came with the series of privately commissioned *egoyomi* designed by Harunobu for New Year 1765. These were lavishly produced on thick *hōsho* paper using elaborate printing techniques and as many as eight printed colours. Commercial production followed immediately and the multicolour print known as *nishiki-e* was soon established.

The materials used in the production of *ukiyo-e* prints were extremely important to the end result and it is necessary to understand their particular qualities in order to comprehend the complexity and skill of the entire process.

Paper

The paper – or *washi* – used in Japanese woodblock prints was primarily made from the long fibres of the paper mulberry or *kōzo* plant (*Broussonetia kajinoki*). The majority of paper was originally produced by farmers in the mountainous regions of Japan who spent the winter months making paper, when work in the fields was less urgent and conditions for papermaking ideal. The first task was to harvest the *kōzo* branches, strip off the bark and separate the inner part from the outer; a process facilitated by both soaking bundles of bark strips in the running water of streams and by steaming them to soften the fibres. Having discarded the bulk of the dark, 'unwanted' outer bark, the inner bark was boiled and washed again – mountainous regions being ideal with such abundant supplies of pure water. It was then carefully picked over by hand and any remaining impurities were removed, a painstaking process that involved hours of careful examination. Now softened, the inner bark was pounded with a wooden mallet to separate the fibres sufficiently to produce a pulp that was placed in a vat containing water and *neri*, a mucilaginous starch that helped to prevent the fibres from clogging and sinking. The papermaker formed the sheet by scooping out a portion of the suspension onto a bamboo screen, supported by a wooden frame. A skilful rocking motion allowed the fibres to distribute evenly over the screen whilst the water drained away, and depending on the thickness of the required paper, it could then be dipped back into the suspension to build up further layers of fibres. Once

the sheet was formed, the bamboo screen was tilted to let any remaining water run away before the paper was transferred directly to a pile of wet sheets. The pile was built up one sheet on top of another and, at the end of the day, pressed overnight to eliminate still more water. Remarkably, the sheets did not stick together; instead, with the aid of a cotton thread laid carefully along the edge of each sheet as it was formed and placed on the pile, the sheets were peeled apart and brushed onto wooden boards which were placed in the sun to dry.

Many different types of paper were produced. The early *nishiki-e* by Harunobu and his school that followed the privately-commissioned calendar prints were printed on the same high quality, relatively thick *hōsho* paper, which responded well to the techniques being employed (Plates 12–16). This paper was later used for the luxuriously produced prints known as *surimono* (Fig.4), which were privately-commissioned and printed for special occasions. These were the exceptions however. Most *nishiki-e* were printed on a *kōzo* paper called *masa* – a generic term for all but the highest quality *kōzo* papers. The overall advantage of these papers was that the length of their fibres gave them tremendous strength, which allowed for the repeated wetting and rubbing of the sheets without any damage occurring – a process that would have been impossible on most Western papers. The size of the sheets of *washi* produced was largely responsible for the standardisation of the different *ukiyo-e* print formats. The expense of paper led publishers, artists and printers to be economical in the way that the paper was divided up, and so most print sizes were neatly divided fractions of a whole sheet: *ōban* format (390 × 265 mm) was half of the *ōbōsho* sheet; *chūban* (290 × 220 mm) was a quarter of an *ōhiro-bōsho* sheet; and *hosoban* (330 × 150 mm) was a third of a *shōbōsho* sheet.

Woodblocks

The woodblocks used to produce the prints were made from a close-grained, well-seasoned wood – often the white mountain cherry (*shiro-yamazakura* or *Prunus mutabilis*) – which was cut along the grain. It was soft enough to carve and yet sufficiently sturdy to withstand the pressures of repeated printing. The high cost of the wood meant that both sides of a block were often cut (as is the case with the block illustrated in Fig.3), and many were planed down at the end of a print run and reused, thus blocks that started out more than thirty millimetres in thickness might end up just ten millimetres thick. The great innovation of introducing colour into the print process itself was attended by the technical difficulty of aligning the individual colours within the black (and later, sometimes blue) outline that is so important to the *ukiyo-e* style. Although not every coloured area had its own block (sometimes the overprinting of two colours was used to produce a third), a typical *ukiyo-e* print in the

FIG. 3 Woodblock carved with an outline-block design by Kikukawa Eizan (1787–1867) for a print in the series *Amusements of the Yoshiwara Niwaka festival at its zenith (Seirō niwaka zensei asobi)*. 1807. The other side was carved with a design by Katsukawa Shunsen (1762–c.1830) of the actor Nakamura Keishi's arrival from Osaka in 12/1805. 390 × 265mm. Given by A. G. W. Murray 1916

early period required two or three woodblocks, with the number increasing to about eight by the time of Harunobu and then to as many as twenty by the mid-nineteenth century. Each time the paper was printed brought a risk of misalignment and blurring. To overcome this potential difficulty, the block-cutters introduced a system of registration marks known as *kentō* which were regularly carved on all blocks. They consisted of two separate points of registration, usually in the bottom left corner and along the longest adjacent edge, as seen in Fig.3. The corners on the opposite side of the block

FIG. 4 Katsushika Hokusai (1760–1849), *Block-cutting and printing surimono*.
Colour print from woodblocks, with metallic pigments and blind-embossing
(*karazuri*). *Surimono*, 213 × 188mm. 1825. Given by E. E. Barron 1937 (P.438-1937)
The man is cutting a block while the woman prints by applying pressure on the
back of the paper with a *baren*. She is working through the pile of dampened
paper in front of her and transferring the printed sheets to the pile on her left.

were often left slightly raised to prevent the paper from sinking down onto the inked areas during printing and possibly smudging the ink. The texture of the woodgrain was used to achieve a subtle pattern on the prints and is one reliable method of testing for authenticity (see the sky in Plates 54 and 58). The block-cutters had a large range of implements at their disposal but mostly used a few simple tools: the main cutting knife was called a *tō*, the flat-bladed implement used to clear excess wood was called the *aisuke* and the chisels, *nomi*.

Pigments

The pigments available to the makers of *ukiyo-e* prints were fundamentally the same water-based organic and inorganic compounds that were used by painters in Japan at that time (although there were exceptions such as the naturally occurring mineral pigments malachite and azurite, which lost their intensity when ground sufficiently fine for printing and were therefore rarely used). The pigments were prepared in individual porcelain bowls and ground and mixed to the correct consistency (Fig.4 and Plate 53) – a process that apprentices in the print studio would have to learn. The organic pigments were extremely sensitive to light and sadly many have faded to a mere hint of their original intensity (most notably the reds, pinks and yellows), whilst the blues and purples have often changed hue altogether, becoming various shades of tan and buff. Those most commonly used were:

sumi carbon black ink, usually made from soot and deer horn glue set into sticks and ground down with water on an ink stone, as required (not light sensitive). It was capable of a variety of tones from dense black to pale grey.
beni delicate, rose-red made from safflowers.
ai indigo blue.
tsuyugusa dayflower blue. This colour was even more sensitive to light than indigo and thus very few prints survive with this pigment intact.
ukon yellow made from the root of tropical turmeric.
kusashiō yellow gamboge. Further shades of yellow and brown were obtained from unspecified flowers and tree barks.
 The most commonly used inorganic pigments included:
tan an orange-red pigment made from lead, sulphur and saltpetre.
shu a vermilion red.
benigara ferric oxide, earth pigment.
shiō a bright yellow, toxic compound of sulphur and arsenic.
empaku white lead carbonate.

Although by modern standards their palette was limited, the printers could mix the available pigments, either before printing, or by overprinting, to produce further colours: for example in Plate 42,

the colour of the horse was achieved by overprinting the grey/blue pigment onto the flesh tone and the pale green canopy sheltering the traveller was the result of printing the yellow over the pale blue.

 The use of metallic powder pigments was adopted on some of the early hand-coloured prints to create an impression of gold or silver without incurring the expense of the metals themselves. In the print by Kiyomasu (Plate 3) the metallic powder was applied by first painting the chosen area with *nikawa* and then sprinkling the pigment over the print; when it was later dry, the excess pigment was dusted away to leave it adhered only to those places where the glue had been applied. From about 1790 mica (*kira*) was used to produce a glistening iridescence; mixed with another pigment, Sharaku set many of his actor portraits on such a background (Plate 9) and Gekkō, for example, used it to achieve a subtle shimmering in the sky of some prints (Plate 61).

 The pigments *tan* and *empaku* are often seen to have darkened due to a chemical change in their lead component as a result of either exposure to atmospheric hydrogen sulphide or contamination from pigments containing sulphide. In recent years there has been debate as to whether these effects were in fact intended by the artists and it has been argued that a certain differentiation can be seen in the type and extent of the discolouration.[1] For example, the darkening of the *tan* pigment in Plate 19 is of a lighter and less defined nature than that seen in Plate 53, where the *tan* on the costumes of the figures has become such a dense and uniform silvery grey that it would appear to have been darkened deliberately. Whether intentional or not, in many cases it has produced a beautiful and subtle patina on the prints.

 By the nineteenth century printers could buy most pigments in a semi-processed form and the early organic pigments were gradually being replaced by brighter, commercially produced chemical pigments. In the 1820s Japan saw the introduction of Prussian or Berlin blue (*berorin-ai*) imported from China and the West. The success of its first use in a major print series by Hokusai (Plates 34-5) led to its widespread adoption by other artists in the 1830s. Around 1864, synthetic (aniline) dyes were introduced. Whilst they were sensitive to light and tended to fade rapidly, the colours they produced were extremely bright (see the pinks in Plate 60) and opened up new aesthetic possibilities for achieving dramatic effects.

Making the print

An *ukiyo-e* print started with a rough sketch (*gakō*) which the artist executed on a thin, but frequently rough, *kōzo* paper using a deer hair brush and *sumi* (Fig.5 shows such a *gakō* with the addition of red). The *gakō* was refined to produce a very precise 'final' drawing called the *hanshita-e* (Fig.6) – the design from which the outline block (*omohan*) was cut. This too was executed in *sumi* but on a more

required great skill as it was easy both to spoil the paper and to distort the design. In order to see the outline more clearly, once the paste was completely dry, a thin layer of the paper was gently rubbed away from the verso with the flat of a finger and sometimes hempseed oil was brushed gently over the surface to render the paper translucent. The most skilled block-cutter in the studio then proceeded to cut the outline through the paper into the wood, the *hanshita-e* being destroyed in the process. Although some *hanshita-e* survive to this day, it is thought that they were either made for prints that were never executed (as is the case in Fig.6) or copied before the print was produced.

The finished outline block was passed on to the print studio to make a series of proofs. Before any printing could take place, the printer had to prepare the paper, firstly by cutting it and then applying size (a solution of *nikawa* and alum in warm water) with a large, flat brush. Sizing was necessary to render the paper less absorbent and thus prevent the pigments from bleeding and to help secure any short fibres that might otherwise adhere to the block. The paper was hung to dry thoroughly before being dampened again to aid with the uptake of the pigments. It took great skill to perfect the exact humidity of the paper in order to ensure that it was neither too wet, when the colours might blur, nor too dry, when the colours might not be retained. Since the weather could affect the moisture content of both the paper and the woodblocks, printing was often carried out in the relatively dry winter months when a uniform humidity could be depended upon.

To print, the face of the block was moistened with water and the pigment (*sumi* in the case of the outline proofs) was applied with a small 'flicker brush' made of slit bamboo leaves. Small horse hair brushes with short bristles were used to work the pigment into the raised areas of the block, with rice-starch paste being mixed into the pigment on the block itself in some cases. The printer then laid down the paper and rubbed over the surface with a coiled bamboo pad called a *baren* (see Fig.4), using rhythmical circular or semicircular movements. No mechanical press was ever used. Outline proofs (Fig.7) were handed back to the artist to be marked with his intended scheme of colours and effects and then returned to the block-cutter. The block-cutter pasted the proofs face down onto individual blocks and cut the number required for all the specified colours and special effects, carefully copying the *kentō* from the outline proof to ensure exact alignment during printing. Fig.8 shows the same area of the print by Kuniyoshi seen in Fig.7, but this time the outline block is printed together with all the colour blocks.

The printer would undertake the final production in accordance with the artist's instructions, but relying on his own skill to achieve some of the beautiful and subtle effects for which *ukiyo-e* are renowned. In general, the softer hues (often the natural, organic pigments) were printed before the stronger colours and the blacks – even the outline block itself was sometimes printed towards the end

refined, very thin *kōzo* paper. It was handed over to the block-cutter, sometimes with specific instructions such as those recorded in a note from Hokusai to the publisher Sūzambō, dated 1/17/1836.[2] In his letter, Hokusai urged the block-cutter to take great care lest he should lapse into the popular Utagawa style when carving the facial features of his figures, and the artist even went to the length of including drawings in his letter to clarify the point and avoid any possibility of misunderstanding. The block-cutter pasted the *hanshita-e* face down onto a block using rice starch paste; a process that

FIG. 6 Katsushika Hokusai (1760-1849), *Sakyō no Dayū Michimasa*. Finished 'block-copy' drawing (*hanshita-e*) for woodblock print in the series *One hundred poems by one hundred poets as explained by a nurse (Hyakunin isshu uba ga etoki)*. 255 × 373mm. *c*.1836-8. Ricketts and Shannon Bequest 1937 (PD.3942-1937)

of the process. The printer would sometimes hand-wipe the blocks to gradate the pigment (*bokashi*) – a technique which greatly increased the sense of depth and recession in a print, and which is frequently seen in the sky and water of landscape prints (the sky in Plate 49 clearly demonstrates this effect). The dense black (seen for example in the actor's hair in Plate 55) was achieved by printing *sumi* on *sumi* using the best available pigment with an extra addition of *nikawa*, and then burnishing the surface with a piece of ivory or tooth in a technique known as *tsuya-zuri*. Burnishing was also used to produce texture, known as *karazuri* (blind printing or embossing); this technique usually required a separate, deeply carved block

and is best examined in raking or slanting light. The paper was dampened as for 'normal' printing but no pigment was applied to the block. The printer would align the paper with the *kentō* and burnish the design into the paper, using either the *baren* to give a soft impression or a piece of ivory or bone to leave a very precise indentation. This technique can be clearly seen on a number of the plates but particularly notable is the snow in Plate 12 and the collar of the actor in Plate 55. Deep 'uninked' outlines (*kimedashi*) were also printed in this way, sometimes using a small hammer to tap the paper gently into the design carved on the block; it was often used to give extra volume to the figures as seen in Plates 14-15. Other

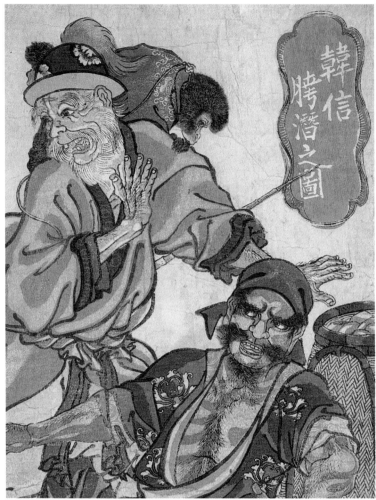

FIG. 7 Utagawa Kuniyoshi (1797–1861), *The humiliation of Kanshin* (*Kanshin mata-kuguri no zu*). Outline-block proof printed in black. Detail of *ōban* triptych. *c.*1842–6. Purchased 1973 (P.11-1973)

FIG. 8 Utagawa Kuniyoshi (1797–1861), *The humiliation of Kanshin* (*Kanshin mata-kuguri no zu*). Colour print from woodblocks. Detail of *ōban* triptych. *c.*1842–6. Given by T. H. Riches 1913

techniques used by the printers to enrich their work included tex-tile-printing (*nunome-zuri*), in which textured fabrics or gauze was glued onto the block and then burnished into the paper (the back-ground in Plate 32 and the hanging scroll in Plate 60).

Until the twentieth century no attempt was made to classify Japanese prints into editions. The prints themselves carry no formal marking system to indicate whether a print was an early or late impression and the blocks were never officially cancelled. Although documentary evidence on the subject is scarce, it is generally believed that batches of up to two hundred prints would have been printed at any one time and then the blocks would have been allowed to 'rest' and dry out. Depending on the popularity of a print, a number of printings might have followed, with several thou-sand impressions being possible before there was significant wear to the blocks. Blocks with delicate lines would have worn first, and this

often shows in the cartouche with the title or artist's signature. Later printings might show a deterioration in quality for a variety of rea-sons: colours were changed, worn blocks were replaced or omitted, and less care was often taken with the printing process itself. Fur-thermore, with the obvious financial gains available, woodblock copies were made to imitate popular prints; but although very skil-fully executed they often lack the vibrancy of line, subtle gradations of tone and depth of recession found in the originals.

NOTES

1. J. Walsh, 'The Identification of deliberately discoloured red leads in Sino- and Russo-Japanese war prints' in E. de Sabato Swinton, *In battle's light: woodblock prints of Japan's early mod-ern wars*, Worcester, 1991, pp.134–6.

2. R. Lane, 'Sugimura waves, Harunobu breasts, and . . . Bette Davis eyes', *Andon*, no.7, 1982, p.17.

Plates

All measurements are in millimetres, height preceding width. Trimmed prints are often slightly smaller than the format size cited in the Glossary. Dates in the Japanese lunar calendar are cited by the month followed by the year in its Western equivalent; *ie* 1/1784 is the first month of the year that actually began on 22 January 1784 according to the Western calendar. The discrepancy occurred because the twelve lunar months only added up to 354 days, and an extra thirteenth month was periodically inserted to prevent New Year's day from occurring too long after the winter solstice, and the years from getting out of step with the seasons. New Year usually occurred between the third week of January and the third week of February in the Western calendar. Japan adopted the Western calendar in 1873.

Hishikawa MORONOBU *c.*1618-94

1

Music under the cherry trees at Ueno
Print from woodblock in black (*sumizuri-e*), with
slight hand-colouring. *Ōban*, 271 × 400. *c.*1680.
Given by the Friends of the Fitzwilliam 1944
(P.8-1944)

Moronobu was already hailed by the early
eighteenth century as the founder of the *ukiyo-e*
school. He was born into a family of fabric dyers
and embroiderers at Hota in Awa (now Chiba)
Province on the far side of Edo Bay, and probably
trained with his father before moving to Edo. His
first signed work was an illustrated book dated 1672,
and he went on to design illustrations to numerous
woodblock books and albums that played a large
part in shaping the artistic character of the newly
emerging culture of the floating world (*ukiyo*). He
was the first *ukiyo-e* artist known by a large body of
signed works, although in the case of many paintings
there is much debate as to which might be the work
of the numerous pupils who worked in his studio.
His designs established themes that were to
dominate *ukiyo-e* over the next century: historical
subjects from China and Japan, genre scenes, land-
scapes, birds and flowers, warriors, courtesans in
the Yoshiwara, and erotic *shunga* ('spring pictures').
His many series of prints in album form were the
immediate precursors of the single-sheet *ukiyo-e*
print (*ichimai-e*).

From the series of twelve prints entitled *Ueno
hanami no tei* (Cherry blossom viewing in Ueno),
which forms a continuous panorama. The set was
presumably issued in wrappers and designed to be
mounted in an album. A complete set mounted as a
hand-scroll, with the title inscribed on the first
sheet, is in the Museum of Fine Arts, Boston. The
figure groups are disposed across the prints very
much in the manner of Moronobu's painted scrolls.
This scene, the sixth in the sequence, shows a group
of women and men from a high-ranking *samurai*
household behind the shelter of a curtain (*maku*),
enjoying a picnic lunch and listening to three of
their number give an informal musical performance
on a *koto* (thirteen-stringed transverse harp),
shamisen (long-necked instrument with three
strings) and *shakuhachi* (curved bamboo flute). They
have chosen a spot with a good view of the cherry
blossom. Moronobu was particularly fond of
depicting scenes of pleasure in and around the
neighbourhoods of Edo, and these were often
connected with the numerous seasonal events or
festivals celebrated at fixed dates based on the lunar
calendar. One of the most important is *hanami*
(cherry blossom viewing), a recurring theme in the
work of Moronobu and his followers. Ueno, the
hilly district in the north of Edo, is still a popular
place for the viewing of cherry blossom in spring.

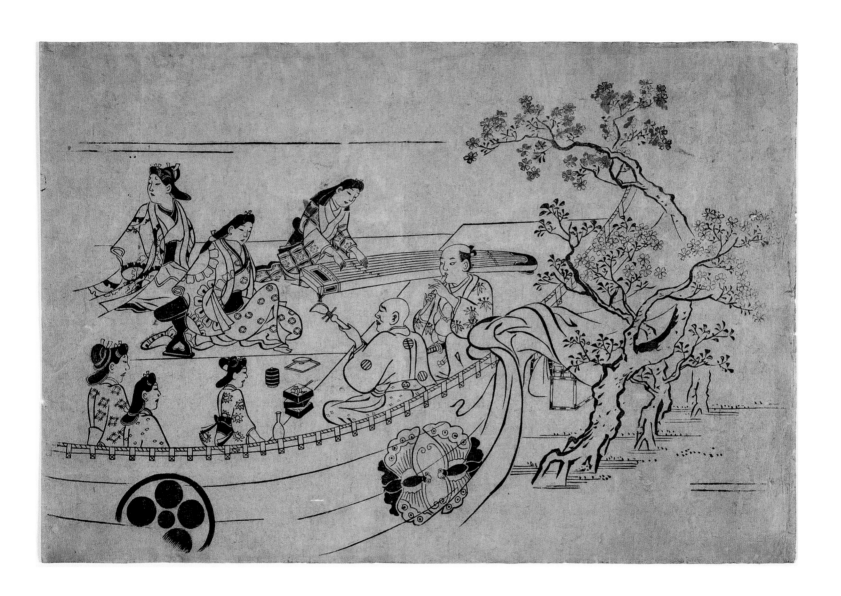

2

Shōki, the demon queller

Print from woodblock in black, with hand-colouring and 'lacquer' (*urushi-e*). *Kakemono-e*, 623 × 255.
Signed: *Hōgetsudō Okumura Bunkaku Masanobu kin-zu*. Artist's seal: *Tanchōsai. c.*1745.
Purchased from the Gow fund with the assistance of the National Art Collections Fund and the MGC/V&A Purchase Grant Fund 1996 (P.382-1996)

Masanobu was a seminal figure in the history of *ukiyo-e* printmaking. Although largely self-taught, he studied for a while with Torii Kiyonobu (1664-1729), and his work was influenced by Hishikawa Moronobu (see Plate 1). A proprietor of a shop dealing in illustrated books and prints, he designed his own books as early as 1701 and published his own prints from 1724. He influenced the entire course of the *ukiyo-e* school and established many of the standard formats of Japanese prints. He was perhaps the first to adopt the technique of *benizuri-e* (two- or three-colour printing) in 1742. He pioneered *hashira-e* (pillar prints), *uki-e* (views with a European system of perspective), and *urushi-e* ('lacquer pictures'). He also established the fashion for single-sheet prints of beautiful women (*bijin-ga*), which became one of the mainstays of *ukiyo-e* print production over the next one-and-a-half centuries.

Shōki was the Japanese name for Zhong Kui, a figure from Chinese mythology. He committed suicide in shame after failing to pass the state examinations, and when his body received a respectful burial, his grateful spirit visited the court of the Tang dynasty emperor Ming Huang during an illness to protect him from fever demons. When the emperor recovered he gave Shōki his blessing in his crusade to rid the empire of all demons. Paintings and prints of Shōki were often hung on Boy's Day as an example of loyalty and perseverance, or at other times to protect households from disease. The traveller Engelbert Kaempfer recorded in the 1690s that the Japanese pasted Shōki's picture 'on their doors, being hairy all over his body, and carrying a large sword with both hands, which they believe he makes use of to keep off, and as it were to parry all sorts of distempers and misfortunes, endeavouring to get into the house'.

Masanobu, like many other artists, designed numerous prints of Shōki in both this *kakemono-e* (hanging-scroll print) format, and in the narrower *hashira-e* format (see Plate 10). *Kakemono-e* were introduced by Masanobu after larger thick paper became available in the 1730s, and were actually sold in paper mountings as hanging-scrolls (a print by Harunobu of the late 1760s shows a woman holding a print by Masanobu mounted in this way). Shōki was one of a number of Chinese subjects that continued to be depicted in Chinese costume in the style of the academic Kanō school, which was based on Chinese ink paintings of the Song period.

This print has subtle hand-colouring in pink and grey, and is an example of *urushi-e* ('lacquer pictures'), in which animal glue (*nikawa*) was mixed with the carbon black ink (*sumi*) and burnished in some areas to a shiny surface in imitation of the effects of Japanese lacquer ware.

3

The actors Mimasuya Sukejūrō as Hyōbanshi Hyōsuke and Matsushima Hyōtarō as Shima no Chitose
Print from woodblock in black, with hand-colouring, metallic dust and 'lacquer' (*urushi-e*). *Hosoban*, 323 × 149.
Signed: *Torii Kiyomasu hitsu*. Publisher: *Sakai-chō Nakajimaya hammoto* (Nakajimaya). 1724.
Purchased 1955 (P.11-1955)

The Torii school of printmakers was founded at the end of the seventeenth century by Torii Kiyonobu I (1664-1729) and his brother Kiyomasu I (died *c*.1717). Torii artists dominated the field of *kabuki* theatre prints before the Katsukawa school developed a more realistic style of actor print (see Plate 6). The genealogy of the second generation of Torii artists is somewhat confusing, but it appears that Kiyomasu II was the second son of Kiyonobu I and the son-in-law of his uncle Kiyomasu I, whose name he adopted in 1718. As with his elder brother Kiyonobu II, his work consisted mainly of theatre-bills, signboards, illustrated programmes and souvenir actor prints, which were the speciality of the Torii school. The school continued well into the twentieth century, but its greatest achievements date from the period before colour-printing was developed in the 1740s and 1760s.

This print shows a scene from the play *Bankoku Taiheiki* (A *Taiheiki* of many lands) performed at the Ichimura Theatre in Edo in the eleventh month of 1724. The original *Taiheiki* (Record of the great peace) was a famous fourteenth-century military chronicle (see Plate 61). The performance depicted here marked the debut on the Edo stage of the actor Matsushima Hyōtarō, who is seen playing the female lead. He had only just arrived in the city and returned to his native Kamigata region (Kyoto – Osaka) after only one year. The other actor, Mimasuya Sukejūrō I (1669-1725), died in the third month of 1725.

Kabuki nempyō (a chronological history of *kabuki* compiled from contemporary sources) records that when Hyōtarō first walked on stage and formally greeted the audience as a newcomer, Sukejūrō suddenly stood up in the audience disguised in a deep sedge hat (*amigasa*) and made a long elaborate speech. In the following scenes, Hyōtarō played the character of a courtesan processing to an assignation tea-house, then assumed the false guise of a lady-in-waiting who was terrified when she came upon Hyōsuke. It is not clear in the print precisely which scene is depicted, although Hyōtarō looks as though he is playing a courtesan. The characters are shown in front of a painted screen in a room with a verandah; there is a basin for washing hands beyond the verandah.

During the years 1720-40, increasingly elaborate hand-colouring was introduced. In this case the red pigment has been mixed with glue (*nikawa*) to produce a glossy effect. The print was backed in the nineteenth century with a page from *Ansei kemmonroku*, an account of the Ansei earthquake of 1855, which has recently been removed to reveal an ink drawing of two heads on the back of the print.

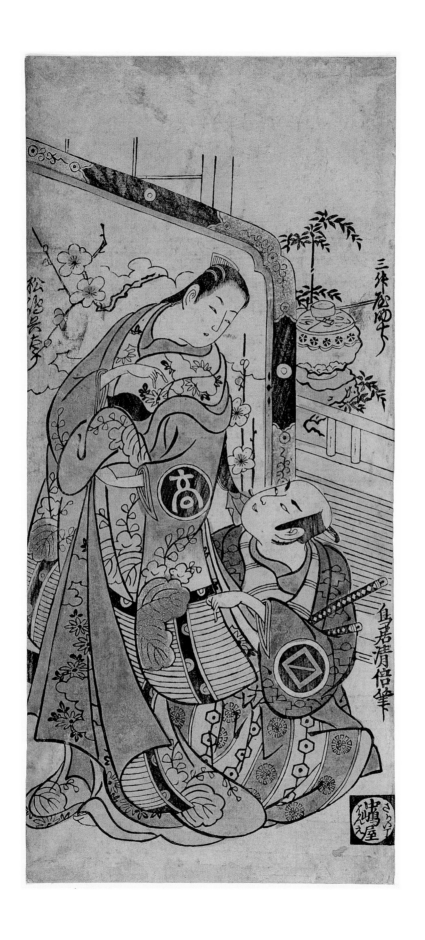

Torii KIYOMITSU 1735-85

4
Actors on a bridge at sunrise
Colour print from woodblocks. *Hosoban*, 311 × 143.
Signed: *Torii Kiyomitsu hitsu*. Publisher: *Yamashiro han*
(Yamashiroya). *c.*1757-62.
Given by T. H. Riches 1913

Kiyomitsu was the second son of Kiyomasu II and
the third generation head of the Torii school (he was
succeeded by his pupil Kiyonaga, see Plate 19). He
continued the school's duties of producing actor
prints, billboards and playbills for the Edo *kabuki*
theatres. Although he played a part in the develop-
ment of the multicolour print in the years
1760-5, thereafter his work tended to be over-
shadowed by that of Harunobu and Shunshō.
His style is less vigorous than that of his predecessors
in the Torii school, but sometimes he achieves a
compensating grace which foreshadows the work
of Harunobu.

Three actors walk across the bridge of a castle –
possibly Yodo Castle on the River Yodo between
Kyoto and Osaka, which was famous for its
waterwheel. The two actors in female costume
probably represent Segawa Kikunojō II (who
adopted this name in 1756), and Bandō Hikosaburō
II (who took this name in 1751). They are followed
by an actor of the Ōtani family, and given that the
poem at the top suggests that he is an actor at the
start of his career, he is more likely to be Ōtani
Hiroji III (who adopted this name in 1762) than
Ōtani Hiroji II (who died in 1757). The poem, a
senryū (comic *hokku*), makes reference to the rising
sun, and can be roughly translated as:

> *In the footsteps of two [lovely] flowers –*
> *The dawn of a budding [talent].*

This print is an example of *benizuri-e* – the
precursor of the multicolour print (*nishiki-e*) – using
black and two basic colours, rose-red (*beni*) and
green; on occasion an extra block was used, which
in this case has faded from blue to grey.

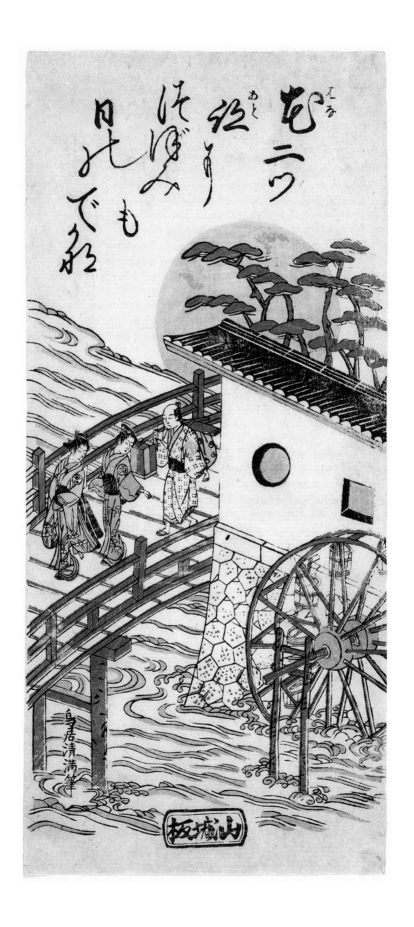

Ippitsusai BUNCHŌ active *c*.1755-90

5

The actor Segawa Kikunojō II as the courtesan Maizuru

Colour print from woodblocks. *Hosoban*, 300 × 141.
Signed: *Ippitsusai Bunchō ga.* Artist's seal: *Mori-shi.*
1772.
Given by the Friends of the Fitzwilliam 1941
(P.311-1941)

Born a *samurai*, Bunchō studied Kanō-style painting. With Shunshō (see Plate 6), he developed a more realistic style of actor portraiture in prints, with an interest in the individual's actual likeness (*nigao*). The two artists collaborated in 1770 on the *Ehon butai ōgi* (Picture book of theatrical fans), one of the first books to exploit the effects of multicolour (*nishiki-e*) printing, which by then had been used for several years in the field of single-sheet prints. Bunchō also designed a large number of *bijin-ga* (prints of beautiful women), which show the considerable influence of Harunobu. He gave up printmaking in later life and was most active in the period 1765-73.

Bunchō made two prints showing Kikunojō in this scene from *Furisode kisaragi Soga* (Soga of the long, hanging sleeves in the second month), performed at the Ichimura Theatre from the twentieth day of the second month, 1772. The identity of the actor and the role appear in a written inscription on the other print, in which the positions of Maizuru and the ox were reversed. In both prints, Kikunojō wears a kimono with a 'dancing crane' (*maizuru*) pattern, referring to the character's name, and the ox wears a peony on one of its horns. The performance marked the actor's return to the stage after illness, and print publishers were keen to capitalise on the extraordinary publicity surrounding the occasion. Kikunojō was a leading *onnagata* (male actor specialising in female roles). His literary name was Rokō, and he was often called Ōji Rokō after his birthplace in Ōji, Musashi Province. He was extremely popular and several products and fashions were endorsed by him, including *Rokō cha* (Rokō's favourite tea) and *Rokō musubi* (a sash tied in Rokō's style).

The play was a traditional one for New Year, being one of the many based on the tale of the revenge of the two Soga brothers, Jūrō and Gorō, against their father's murderer, Kudō Suketsune (see Plate 55). Kikunojō II made his entrance as Maizuru via a trap door in the stage, leading what was perhaps a real-life ox with Onoe Kikugorō I as Suketsune mounted on its back. The remainder of the stellar cast assembled for the production, including the characters of Jūrō and Gorō carrying hobby-horses, joined them on the stage to form a complex tableau. The production was vastly successful but the run was cut short when just ten days after the opening night a fire destroyed large areas of the city, including the Nakamura and Ichimura Theatres. Kikunojō's health deteriorated and he died the following year without returning to the stage again.

Katsukawa SHUNSHŌ *c.*1726-92

6

**The actor Ichikawa Danjūrō V
as the monk Shunkan**
Colour print from woodblocks. *Hosoban*, 315 × 151.
Signed: *Shunshō ga. c.*1775.
Purchased 1908

Shunshō, like his contemporary Bunchō, was probably from a *samurai* background. He wrote poetry and was respected as a man of cultivated tastes and wide learning. He was a pupil of Katsukawa Shinsui, and became famous for his portraits of *kabuki* actors in the Meiwa era (1764-72), taking over this role from the Torii school. He was also one of the greatest *ukiyo-e* painters of the eighteenth century. Most of his actor prints were in the narrow *hosoban* format, and many of them were diptychs or triptychs, with one figure on each sheet. They usually showed famous moments from *kabuki* plays, with the actors in poses of particular psychological and dramatic significance. He had a large number of pupils who adopted the first part of his name (Shunko, Shun'ei, etc). Most Katsukawa-school actor prints lack any publisher's mark, although it is not clear whether or not this means that they were privately commissioned by theatre patrons or theatre tea-houses.

Shunkan, head monk of Hōshō-ji Temple in Kyoto, was exiled in 1177 to the remote island of Kikaigajima for his part in an unsuccessful plot against the ruling Taira clan's domination of court and government. Though his fellow conspirators were soon pardoned, Shunkan was left on the island to die. His plight became the basis for a *nō* play by Zeami (1364-1443), and for many more elaborate later versions for *bunraku* and *kabuki*. In the *kabuki* version, Shunkan escapes from the island on a secret mission to guard the emperor's concubine, Kogō no Tsubone, while she gives birth to a royal heir in a remote retreat at Horagadake. As midwife, Shunkan enlists the services of Oyasu, a girl from the local village who is a secret supporter of the Genji cause. To persuade Shunkan and the noblewoman that she can be trusted with the secret of their true identities, Oyasu is about to swear an oath of secrecy on a pair of metal hand-mirrors, just as a warrior would swear an oath on his sword. Shunkan, fearful of revealing his secret, grasps hold of her hand, but as he catches sight of his aged and careworn features in one of the mirrors he is overcome and inadvertently lets slip the story of his lonely exile.

This print shows the moment when Shunkan gives away his identity, holding the mirrors in either hand. It may be part of a diptych, with the missing sheet showing Oyasu. Shunshō combined Shunkan and Oyasu in a print showing the same moment, designed on the occasion of the performance of *Hime komatsu ne no hi asobi* (Outing to pick pine seedlings on the rat-day of the New Year) at the Ichimura Theatre in the ninth month of 1768, with Sawamura Sōjūrō II as Shunkan. A very similar design to the present print appears in a print by Shunshō's pupil Shunkō (1743-1812), showing Nakamura Nakazō I in the role of Shunkan on the occasion of the performance of the same play at the Ichimura Theatre in the seventh month of 1778. In Shunkō's print, which was also probably part of a diptych, Shunkan only holds one mirror.

Danjūrō V also appears in Plate 8.

7

Three actors in a scene from the play
Yukimotsu take furisode Genji
Colour print from woodblocks. *Ōban*, 362 × 250.
Artist's seal: *Hayashi* in jar-shaped outline. 1785.
Purchased from the S. G. Perceval Fund 1960
(P.48-1960)

Shunshō appears to have used this particular form of
his jar-shaped seal to sign prints only in the year
from the eleventh month of 1785 to the eleventh
month of 1786.

The play *Yukimotsu take furisode Genji* (Snow-
covered bamboo: Genji in long sleeves) was
performed in the eleventh month of 1785 for the
opening-of-the-season (*kaomise*) production at the
Nakamura Theatre. The production was a desperate
attempt by the actor Nakamura Nakazō I (1736-90)
to revive the flagging fortunes of the Nakamura
Theatre; it was a flop, and to make matters worse the
theatre burned down in the first month of 1786. The
play was set in the twelfth century and told of the
rivalry between the Taira and Minamoto (Genji)
clans. In this scene three of the principals are shown
on an outing for cherry blossom viewing (*hanami*),
with a curtain attached to the tree in the
background to make a flower-viewing enclosure, in
a similar manner to that seen in Moronobu's print
(Plate 1). In the centre is the actor Nakayama
Kojūrō VI (a stage-name used by Nakamura Nakazō I
in this year) in the role of Chinzei Hachirō
Tametomo disguised as Lady Hotoke (Hotoke
Gozen), who is performing a dance. On the left is
Osagawa Tsuneyo II as the courtesan Naniwazu.
On the right is Sawamura Sōjūrō III as Komatsu no
Shigemori. Shunshō made several prints of other
scenes from this production, and his pupil Shunkō
designed a *hosoban* format print of Nakayama
Kojūrō VI as Lady Hotoke.

The actor Nakamura Nakazō I was a seminal
figure in the history of *kabuki*. He was the leading
actor of villain roles (*jitsu aku*) in the 1770s and
1780s. He was especially noted for his portrayal
of the robber Sadakurō in Act 5 of *Kanadehon
chūshingura* (see Plate 27). He also established
mimetic dance (*shosagoto*) as a critical part of
leading male roles, when previously it had been the
province of *onnagata*; this opened up the possibility
of more complex dance dramas.

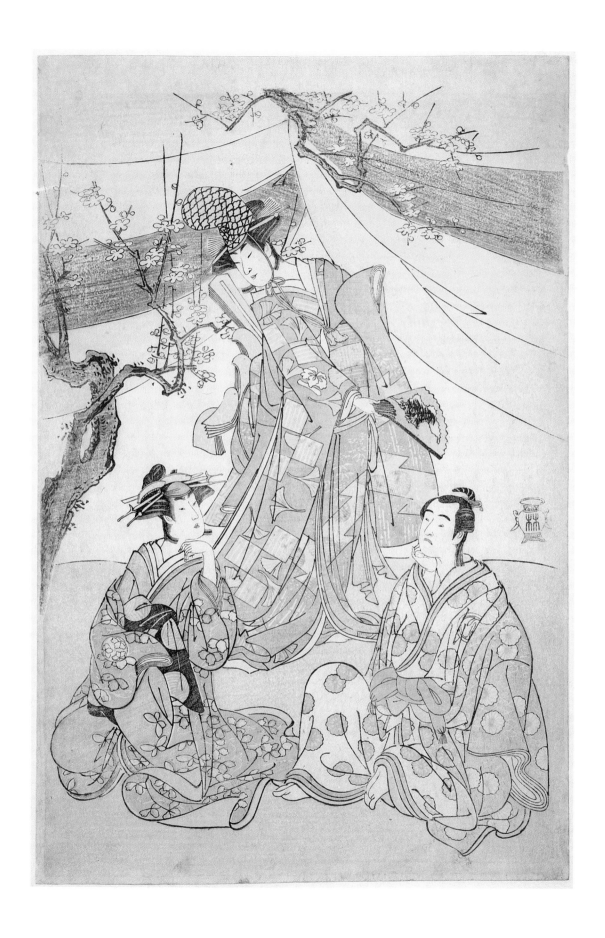

Katsukawa SHUN'EN active *c*.1787-96

8

Ichikawa Ebizō as Soma Tarō Yoshikado, disguised as the itinerant pilgrim Kairyō
Colour print from woodblocks. *Hosoban*, 310 × 142.
Signed: *Katsukawa Shun'en ga*. 1796.
Given by the Friends of the Fitzwilliam 1941
(P.327-1941)

Almost nothing is known about Shun'en except that he worked in Edo, specialised in actor portraits, and was presumably a pupil of Shunshō. His prints are rare.

A depiction of a scene from the play *Seiwa nidai ōyose Genji* (Second generation of the Seiwa lineage: a Genji to draw the crowds), performed at the Miyako Theatre in the eleventh month of 1796. Yoshikado is in a graveyard at night with a spirit fire appearing by his side. He wears the typical disguise of a pilgrim so frequently encountered in *kabuki*, and carries a portable shrine on his back bearing the inscription: *saikoku taikyō* (western provinces, all desires fulfilled).

As was usual in actor prints, the actor's personal crest (*mon*) identifies him; in this case it is depicted on his sleeve. Ichikawa Ebizō was the new stage name adopted in 1791 by Ichikawa Danjūrō v (1741-1806), who also features in Shunshō's print (Plate 6). He was the latest in a line of actors starting with Danjūrō i (1660-1704) who introduced the *aragoto* ('rough stuff') style of heroic acting that came to distinguish the Edo *kabuki* from the soft style (*wagoto*) favoured in Kyoto and Osaka. The epitome of the *kaneru yakusha* (versatile actor), Danjūrō v played a much wider range of roles than any of his Danjūrō predecessors. From his debut as Danjūrō v in 1770 he was the most celebrated actor of his age and was idolised by the public. He retired from the stage a month after this performance opened in 1796, and spent the rest of his years at an elegant retreat on the eastern outskirts of Edo writing *kyōka* verse. He had been an active member of literary groups since the early 1780s, numbering among his circle the writers Ōta Nampo (1749-1823) and Santō Kyōden (see Plate 23), and the young Hokusai (see Plate 32).

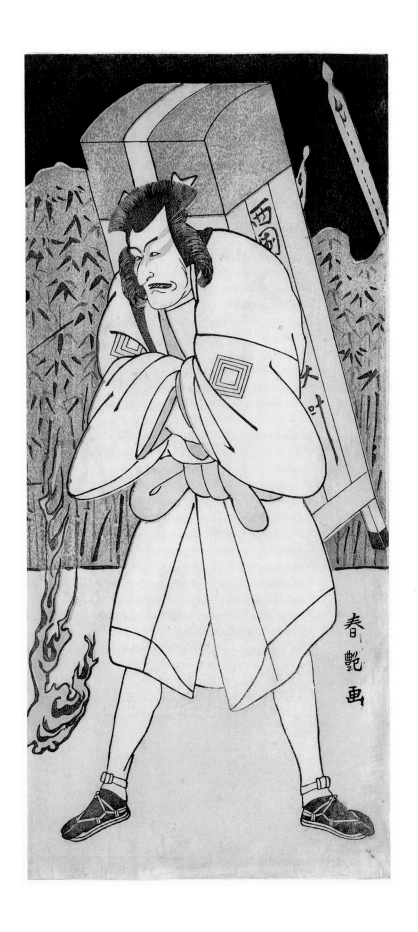

Tōshūsai SHARAKU active 1794-5

9

Ichikawa Omezō I as the servant Ippei
Colour print from woodblocks, with 'lacquer'
(*urushi*) and dark mica ground (*kira*). *Ōban*,
378 × 253.
Signed: *Tōshūsai Sharaku ga*. Publisher: *Tsutaya
Jūzaburō*. Censor's seal: *kiwame*. 1794.
Inscribed by a later hand with the identification
of the actor (top right).
Oscar Raphael Bequest 1941 (P.199-1946)

Sharaku remains an enigma. He appeared suddenly
in 1794 as an accomplished master and disappeared
from the scene only ten months later, after designing
more than 150 *kabuki* actor prints. The first of these
were the twenty-eight large close-up portraits of
actors against a mica ground designed on the
occasion of plays performed in the three *kabuki*
theatres in Edo in the fifth month of 1794. All his
prints were published by Tsutaya Jūzaburō, who had
earlier taken the relatively unknown Utamaro under
his wing (see Plate 25). Never before had any
publisher issued at once so many large-format prints
with such lavish and costly printing effects, and this
is even more remarkable in that the artist was
apparently making his debut. Some scholars have
therefore suggested that the prints may have been
privately commissioned, thereby relieving the
publisher of the initial production costs. An early
account of *ukiyo-e* artists, compiled by the writer
Ōta Nampo in the 1790s, states that Sharaku
'depicted the likenesses of *kabuki* actors, and he
strove so hard to depict them realistically that they
appeared the opposite. This meant that he was
unable to stay long in the world, stopping work after
only a year.' One unproven story, dating back at least
to 1844, tells that he was a *nō* actor called Saitō
Jūrobei in the service of the lord of Awa, and that he
made the prints during the period that his master
was absent from Edo.

One of ten 'large-head' portraits by Sharaku that
depict actors in the play *Koinyōbō somewake tazuna*
(The loved wife's multicoloured leading-rope)
performed at the Kawazaki Theatre in the fifth
month of 1794. The plot was derived from a puppet
play by Chikamatsu Monzaemon (1654-1724) that
had been adapted for the *kabuki* theatre. Ippei was
the faithful manservant of Date no Yosaku, son of
the chief retainer of Tamba Castle. After he had
been entrusted with the safekeeping of the sum
of 300 *ryō*, he was attacked by the villainous
manservant Edohei, who stole the money, thus
causing the disgrace of Ippei's master Yosaku. In
this print Ippei is seen drawing his sword in a
confrontation with Edohei, played in this
production by Ōtani Oniji III, who is portrayed at
the same moment in the drama in another print in
Sharaku's set. Some impressions of this print lack the
red eye make-up.

The 'large-head' (*ōkubi-e*) format had been used
earlier for actors, notably by Shunshō's pupil Shunkō
in 1788-9, but without the mica background. The
earliest datable mica-ground bust portrait of an actor
is an *aiban* format print by another Katsukawa-
school artist, Shun'ei (1762-1819), dating from the
first month of 1794; this may have been the stimulus
for Tsutaya to publish Sharaku's series. The idea for
the *ōban* format probably owes something to the
ōban close-up heads of courtesans against a mica
ground designed by Utamaro and published by
Tsutaya in 1792-3 (see also Plate 26). Sharaku's
striking assemblages of individually observed facial
features contrasts with the more schematised actor
portraits (*nigao-e*) of the Katsukawa school (Plates
6-8). This striving for realism may in part reflect the
kabuki vogue for realism, or 'recreating the truth' (*shō
utsushi*) on the stage, which was one of the responses
to the Kansei reforms of 1789-95.

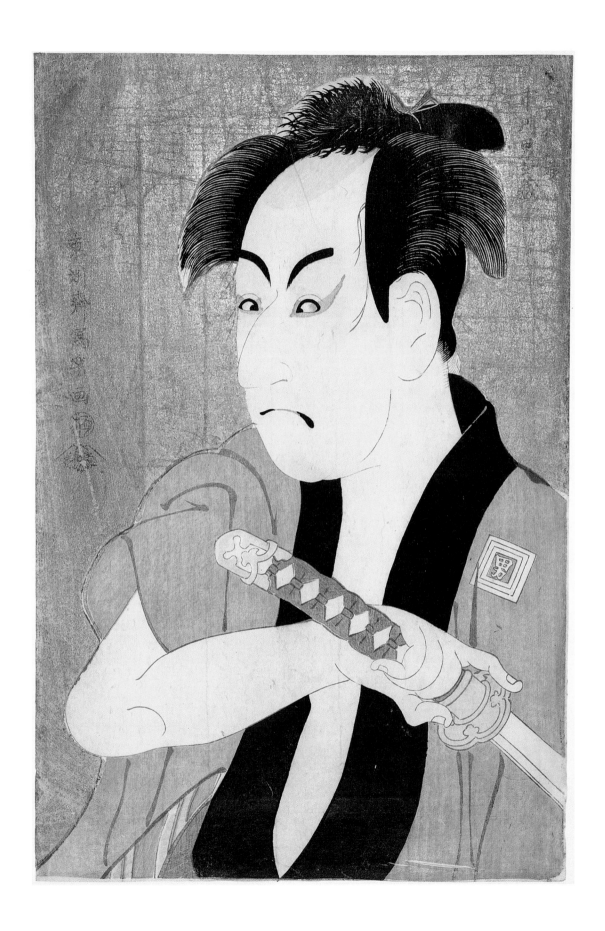

Toyonobu is supposed to have been a pupil of Nishimura Shigenaga (*c*.1697-1756), but he was mainly influenced by Okumura Masanobu and Harunobu. He was one of the first artists to design *hashira-e* in the early 1740s and his career spanned the development from hand-coloured *beni-e* through *benizuri-e* to multicolour *nishiki-e* in the style of Harunobu. He seems to have stopped designing prints around 1765.

10

Parody of the tale of Aridōshi Shrine
Colour print from woodblocks (the yellow added afterwards by hand). *Hashira-e*, 718 × 104.
Signed: *Tanjōdō Ishikawa Shūha ga* and with Toyonobu's seal. Publisher's seal: *Urogataya hammoto* (Urogataya Magobei). *c*.1750s.
Purchased from the S. G. Perceval Fund 1961 (P.127-1961)

This print alludes to the legend recounted by the poet Ki no Tsurayuki (*c*.872-945), which became the subject of the *nō* play *Aridōshi* (literally 'passage of the ants') by Zeami (1364-1443). Tsurayuki angered the god Aridōshi by riding through the sacred temple precincts without dismounting. A sudden rainstorm broke and his horse fell ill, at which point Aridōshi appeared in the guise of the shrine attendant, wearing a raincoat and high wooden clogs (*geta*), and carrying a 'snake's-eye' umbrella (*janome-gasa*) and bronze lantern. He told Tsurayuki that the storm was caused by his disrespectful behaviour and advised him to appease the god. The poet realised that he was actually in the presence of the god by the unusual appearance of stars in the sky on a cloudy day, and composed the following placatory verse:

> *How could I have known*
> *that in this cloudy,*
> *unfamiliar sky,*
> *there dwelt the 'passage of the ants'.*

When Tsurayuki had recited his poem the god rewarded him by curing his horse and performing a Shintō dance.

Hashira-e (pillar prints) derive from the habit of hanging long decorated strips of wood, bamboo, textile, ceramics or paper on the *hashira* – free-standing columns or support pillars that were often exposed when interior sliding screens were removed. This was usually the only place in a room available to hang pictures apart from the alcove (*tokonoma*) specially constructed for this purpose; otherwise, prints had to be pasted straight onto paper doors or screens. The first narrow pillar prints apparently appeared by accident in the 1740s, when the similarly tall but wider *kakemono-e* format became popular for depicting single standing figures (see Plate 2). The blocks for *kakemono-e* were constructed from two planks of unequal width which sometimes split apart. An inspired publisher decided to publish prints from just one of the split blocks, showing the figure incomplete, and the narrower format proved ideal for decorating pillars. These were the first prints in which figures were cut off by the edge of the design, a trait that now seems axiomatic of the *ukiyo-e* style, but did not become widespread in other formats until the 1790s (see Plates 9 and 25-6).

11

Saigyō Hōshi contemplating Mount Fuji
Colour print from woodblocks. *Hashira-e*, 700 × 118.
Signed: *Koryūsai zu*. 1770s.
Given by Mme E. Cuchet-Albaret 1958 (P.58-1958)

Various tales of the life of Saigyō Hōshi (1118-90) were published from the early Edo period onwards and he proved a popular subject in *ukiyo-e* prints. Born a member of the Fujiwara clan, he gave up his family and courtly privileges at the age of twenty-three and became a priest (*hōshi*). On a journey east he glimpsed Mount Fuji for the first time and was reminded of a *waka* (classical thirty-one-syllable poem) by Ariwara no Narihira (825-80) describing how the peak was covered in snow whatever the season. In response, Saigyō composed his own *waka*:

> *Trailing in the wind,*
> *the smoke of Mount Fuji*
> *fades in the sky,*
> *moving like my thoughts*
> *towards some unknown end.*

Koryūsai designed several prints of this episode in *hashira-e* format, which was particularly suited to the composition of the priest, with his pilgrim's hat and staff, gazing up at the mountain.

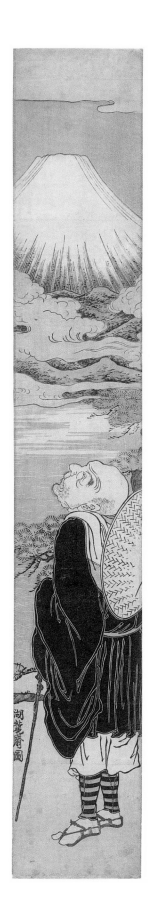

Suzuki HARUNOBU *c.*1725-70

I 2

Lady and her maid walking by a river
Colour print from woodblocks, with blind
embossing (*karazuri*). *Chūban*, 277 × 207.
Signed: *Harunobu ga. c.*1767.
Oscar Raphael Bequest 1941 (P.181–1946)

Harunobu was the leading artist of *bijin-ga* in the
1760s, and the first artist to design multicolour
(*nishiki-e*) prints in 1765. His first prints were of
actors in the Torii style, but he later eschewed the
more earthy aspects of *ukiyo-e* and the expressive
extremes of *kabuki* theatre, creating instead a
dreamlike elegance that echoed the courtly art of
Kyoto and the poetic tastes of literary clients. His
subjects were mainly tea-house girls, young women
going about their daily occupations, and young girls
amusing themselves or their lovers, but his treatment
was infused with poetry and he often introduced
elements of landscape. His delicate figures recall the
ukiyo-e paintings of Kawamata Tsunemasa (active
*c.*1741–51) and he sometimes even borrowed the
figures and compositions of the Kyoto artist
Nishikawa Sukenobu (1671–1750). Most of his
prints were in the *chūban* format, although some
designs were later reworked in other formats such as
hashira-e. He also designed a number of books, the
most famous of which was the five-volume *Seirō
bijin awase* (Beauties of the Yoshiwara) of 1770.

One of a number of prints with the name of a
classical poet and his or her poem inscribed in an
area defined by stylised clouds across the top, and
with elements of the poem illustrated in a modern
setting below. They belong to various untitled series
based on classical poetry anthologies, such as *Sanjū-
rokkasen* (Thirty-six poetic sages), *Hyakunin isshu*
(One hundred poets, one poem each), or *Kokin
wakashū* (Collection of poems past and present),
compiled in the Heian and early Kamakura periods.
Harunobu also designed a book, *Ehon hana-kazura*
(1764), which illustrates all thirty-six poems in the
Sanjū-rokkasen anthology. The designs in the book
appear to have provided the basis for some of these
later single-sheet prints. The poem at the top of this
print is by Ki no Tomonori (active *c.*850–904), a
kinsman of Ki no Tsurayuki (see Plate 10):

> *When evening falls*
> *and the river-breeze begins to blow*
> *over the sandy bed of Saho River,*
> *how the plovers twitter*
> *and cry after their mates!*

The figures are dressed for the snow. They wear high
wooden clogs (*geta*), split-toed linen socks (*tabi*), and
carry 'snake's-eye' umbrellas (*janome-gasa*). The
maid's clogs are simply wooden, while those of her
mistress are lacquered black. The latter also wears a
black winter hood, called a 'high-priest hood' (*okoso-
zukin*) after its appearance on a famous statue of the
thirteenth-century priest Nichiren. The maid carries
a lantern.

Blind embossing (*karazuri*) from a block printed
without ink creates ridges of paper that appear like
ridges of snow.

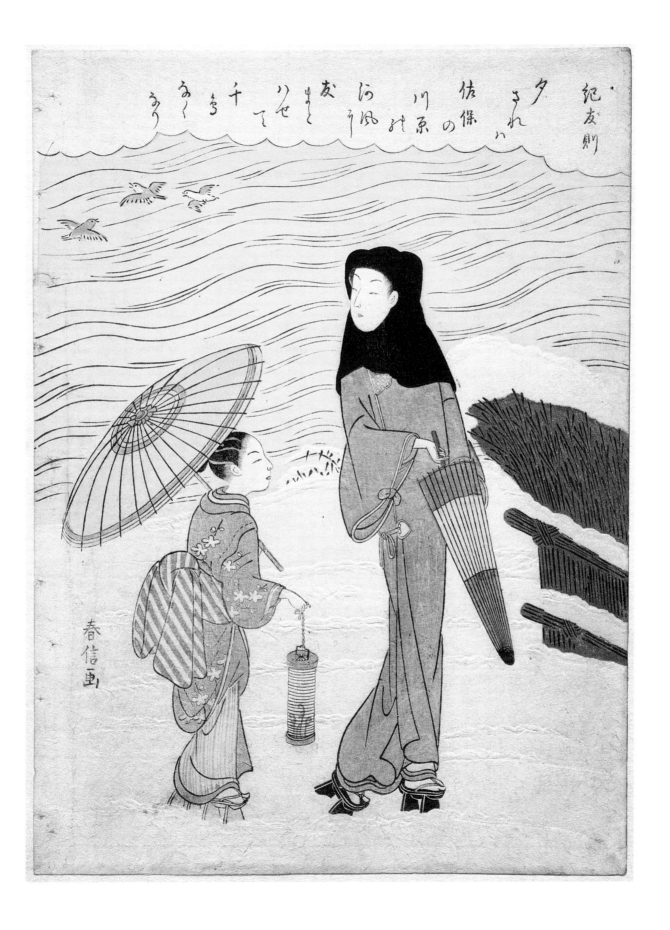

Suzuki HARUNOBU *c.*1725-70

13

A mother dressing her son in a kimono
Colour print from woodblocks, with blind
embossing (*karazuri*). *Chūban*, 264 × 193.
Signed: *Suzuki Harunobu ga. c.*1768.
Given by the Friends of the Fitzwilliam 1941
(P.312-1941)

From an album of five designs called *Fūryū goshiki-
zumi* (Elegant five shades of ink), the title page of
which is in the Museum of Fine Arts, Boston. The
album contained a portrait of the great *hokku* poet
Matsuo Bashō (1644-94), followed by prints
illustrating poems by members of his school. The
phrase 'five shades of ink' (*goshiki-zumi*) derived
from the title of a *hokku* anthology published in
1731, and developed into a poetic term signifying
the number five. It had already been used to indicate
a set of five prints in the title of a series by
Okumura Masanobu, published *c.*1747: '*Hokku*
conjunction of love: five shades of ink' (*Haikai hokku
koi no fugō goshiki-zumi*).

 This print illustrates a poem by the minor *hokku*
poet Nakagawa Sōzui (1684-1744), or his successor
Sōzui 11, which is inscribed at the top in a stylised
cloud:

 Just look at this!
 The crawler is standing up now
 for the change to summer dress.

The *koromo-gae* (change to summer clothes) took
place on the first day of the fourth month of each
year, the time of spring cleaning. The boy is being
dressed by his mother in his new summer kimono
while the maid holds his sash to which is attached
a small purse (*mamori-bukuro*). On the floor lie
favourite toys: a windmill and a doll of Daruma,
the founder of Zen Buddhism.

 Blind embossing (*karazuri*) from a block printed
without ink is used to add an indented pattern to
parts of the women's clothing and to the boy's sash.

Isoda KORYŪSAI active *c.*1766-88

14
Yukenrō
Colour print from woodblocks, with blind
embossing (*kimedashi* and *karazuri*). *Chūban*,
248 × 192.
Signed: *Koryūsai ga. c.*1771.
Given by T. H. Riches 1913

Koryūsai was born a *samurai* in the service of the
lord of Tsuchiya, but he relinquished his rank and
moved to Edo in order to become an *ukiyo-e* artist.
He was probably a pupil of his friend Harunobu,
and after the latter's death in 1770 he became the
leading artist of prints of beautiful women and
the most prolific designer of *hashira-e* (he was
responsible for nearly a quarter of extant pillar
prints; see Plates 11 and 17). His early style is similar
to that of Harunobu although less other-worldly,
but in the 1770s his figures became larger and more
stately in contrast to the slender childlike figures of
his master. It is believed that after 1780 he gave up
designing prints and devoted himself to painting. In
1781 he received the title of *hokkyō*, an honorary,
priestly title often conferred on lay craftsmen.

From the series *Fūryū Yamato nijūshi-kō* (Twenty-
four fashionable Japanese paragons of filial piety).
The title of this series alludes to a fourteenth-
century Chinese book extolling filial piety, which
was one of the central principles of Confucian
philosophy that lay behind Tokugawa society and
education. The many schools set up by the Shingaku
religious movement between the mid-eighteenth
and mid-nineteenth centuries, which propounded a
typical mixture of Confucian, Buddhist and Shintō
ideas, each had a scroll on the theme of loyalty and
filial piety hanging in the alcove (*tokonoma*) in their
main hall.

Each print in this series brings the theme up to
date in a scene featuring fashionable women. Here a
courtesan, with her child-attendant (*kamuro*) beside
her, is seen praying to a constellation in the sky in a
parody of the Chinese paragon of filial piety, Yu
Chenlou (in Japanese: Yukenrō), governor of
Chunling Province in the Qi dynasty (479–501).
One day, Yu Chenlou felt a pain in his heart and
divined that his father, who lived some distance
away, must be ill. When he reached his father, he
found him on his death bed. The physician told
Yu Chenlou that there was only one way to tell
whether his father would survive, which was to taste
his excrement: if it tasted bitter he might live; if it
was sweet, then there was nothing to be done. Yu
Chenlou duly tasted a sample and found that it was
sweet. He then spent the whole night in prayer to
the North Star, beseeching that his own life might
be taken in place of his father's, but to no avail.

15
Lovers in an interior
Colour-print from woodblocks, with blind
embossing (*kimedashi* and *karazuri*). *Chūban*,
202 × 279. *c.*1770.
Given by the Friends of the Fitzwilliam 1994
(P.112-1994)

This belongs to the category of print known as
shunga ('spring pictures'), *higa* ('secret pictures'), or
most frequently in the Edo period, *makura-e*
('pillow pictures'). The term *shunga* derives from the
associations of spring with love. China and Japan
had a long tradition of explicit erotic art. Sex
manuals and courtesan critiques with erotic printed
illustrations began to appear in the 1660s, and erotic
prints became one of the main genres in Japanese
printmaking for the remainder of the Edo period.
Following an edict of 1722 they could not be
published legally, and the names of artist and
publisher were usually omitted for obvious reasons
(without a signature Harunobu's *shunga* are difficult
to separate from those of Koryūsai). Most *shunga*
appeared in the discreet form of albums, with a less
explicit print chosen for the first illustration. In a
similar spirit painted *shunga* usually took the form of
hand-scrolls that could be concealed in the sleeve. It
is not clear whether *shunga* albums were sold under
the counter in the ordinary print- and bookshops,
or what proportion of them may have been
privately issued.

Shunga* overlapped in subject-matter with
the merely mildly sensual prints of lovers and
courtesans, and more particularly with the *abun-e*
(risqué pictures) that gave tantalising glimpses of
flesh through loosely fitting robes (see Plate 17).
Although anatomically explicit, *shunga* are not
exactly realistic. Physical attributes are often
exaggerated and the situations are frequently
improbable, sometimes for the sake of humour.
Many of the prints, including this example, recall
the flavour of the amorous, and often rather far-
fetched, episodes in classical Japanese literature. The
quality of the designs is often high, and the printing
effects can be exquisite, suggesting that they were
carefully produced for connoisseurs who were
sophisticated in their appreciation of the subtleties
of printmaking. In this case the subtlety of the
printing effects around the woman's pudenda
doubtless gave collectors particular pleasure. The
delicately provocative gesture of the woman's hand
as she lightly grasps the uncertain young lover's
wrist often appears in *shunga*, although here there is
an elegant lightness of touch typical of Harunobu.
Although a third figure is often encountered in
shunga as a voyeur, it is less frequently discovered in
the form of a second lover. In this scene the older
lover sleeping through the young man's intrusion
presumably adds a *frisson* to the encounter.

The colours are beautifully preserved and give
a good idea of how the slightly faded colours in
the prints shown in Plates 14 and 16 might have
appeared when fresh. The elaborate and exquisite
embossing is also in fine condition: both in areas like
the wall where it helps to define the pattern, and in
the outlines of the figures and pillows, where it
indents the paper so that the volumes of the forms
swell to give a three-dimensional effect.

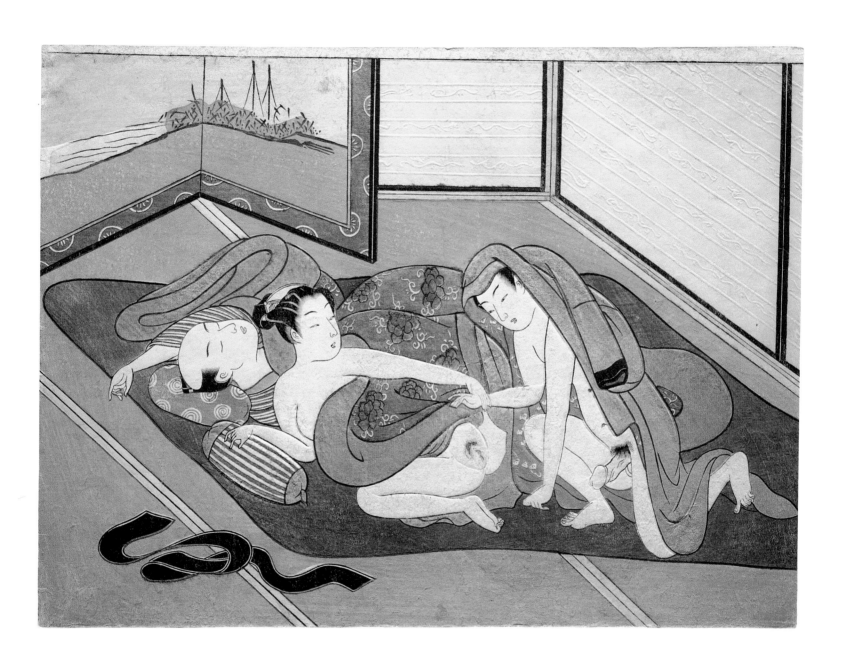

Suzuki HARUNOBU *c.*1725-70

16

Lover taking leave of a courtesan
Colour print from woodblocks with blind
embossing (*kimedashi*). *Chūban*, 269 × 212.
Signed: *Harunobu ga. c.*1768.
Given by T. H. Riches 1913

The theme of lovers reluctantly parting at dawn is
frequently encountered in Harunobu's prints,
usually with echoes of classical literature. According
to *Makura no sōshi* (The pillow book) by Sei
Shōnagon (*c.*966-1017): 'A good lover will behave as
elegantly at dawn as at any other time … Even when
he is dressed he still lingers, vaguely pretending to
be fastening his sash … Indeed, one's attachment to a
man depends largely on the elegance of his leave-
taking.'

In this print, the woman catches at the man's
kimono as he prepares to knot its undertie. A kettle
of *sake* for the cup of parting is on the cabinet
behind the figures. His kimono has a white
geometric symbol repeated on the sleeve, which is
one of the crests (*Genji mon*) identifying the chapters
in the classic novel *Genji monogatari* (The tale of
Genji) by Lady Murasaki Shikibu (*c.*973-1020).
References to the novel were often made in this
way on prints. Although the crest is difficult to make
out here, another print of parting lovers by
Harunobu with a similar male figure clearly bears

the crest for chapter 48, *Sawarabi* (Early ferns). This
chapter, like the rest of *Genji*, is full of poignant
partings, but it does not seem to provide a specific
analogy for either print. The gesture of tugging at
the man's robes to detain him may contain another
allusion – to the famous *kusazuri-biki*, or 'armour-
seizing scene', in Soga plays, in which Asahina
Saburō prevents Soga Gorō from entering a banquet
by seizing the skirt of his armour. Harunobu
collaborated with Bunchō in the design of another
print which explicitly parodies the 'armour-seizing'
with a kneeling man pulling at the skirt of a
courtesan, and with symbols identifying the Soga
characters. On this occasion, the allusion is less
explicit.

This print is also encountered with variant
blocks used for the wall on the right and for the
slopes of Mount Fuji on the painted folding-screen.
The screen is disposed in the picture so that the
landscape almost appears like a view through a
window.

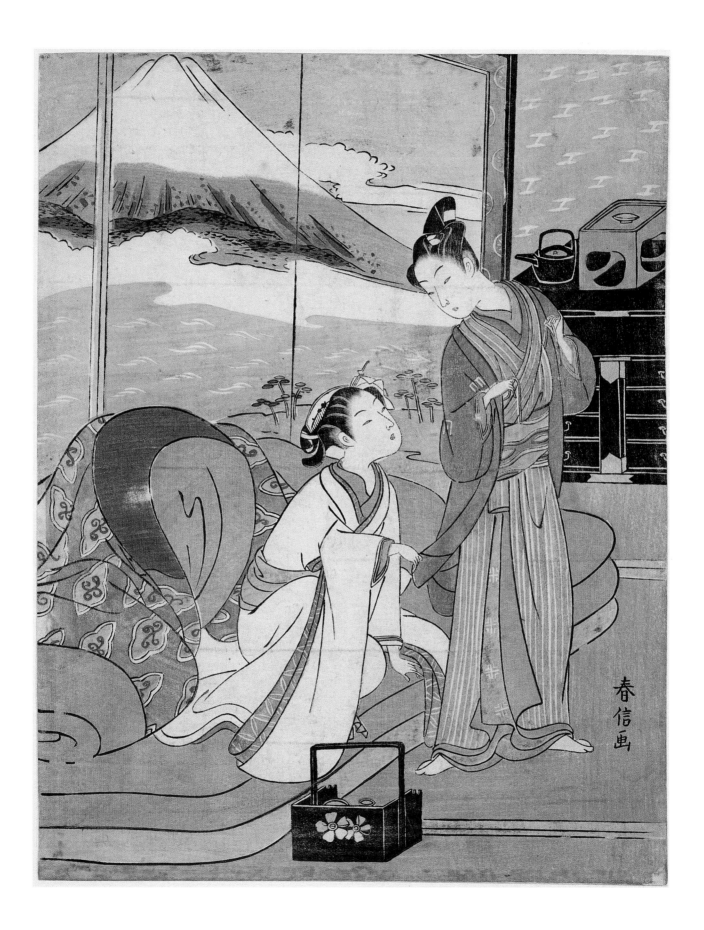

Isoda KORYŪSAI active *c*.1766-88

17

Courtesan returning to her lover
Colour print from woodblocks. *Hashira-e*, 686 × 117.
Signed: *Koryūsai ga. c.*1771.
Given by T. H. Riches 1913

A courtesan returns to her lover who waits for her behind the folding-screen, smoking his pipe. Her white nightgown parts to show her breast and ankle, while still clinging to her form to emphasise the curve of her buttock and the line of her thigh. The proximity of the lovers' meeting is subtly suggested by the juxtaposition of their hands – her fingers curl round the edge of the screen and almost seem to touch his hand that holds the pipe. The way the screen divides the already narrow format, and the picture plane, into still narrower vertical strips, enables Koryūsai to demonstrate his consummate mastery of the *hashira-e* (pillar print).

The provocative glimpse of the woman's body is typical of prints known as *abuna-e* (risqué picture), which became popular after explicit erotic prints (see Plate 15) were made illegal in 1722. The expression *abuna-e* was used as early as 1687 in an *ukiyo-zōshi* entitled *Kōshoku kimmō zui* (Amorous educational pictures), to define the quality of tantalising pictures that show only a glimpse rather than revealing all.

Katsukawa SHUNCHŌ active *c*.1780-1800

Few facts are recorded about Shunchō's life. He was a pupil of Katsukawa Shunshō in the early 1780s, but unusually for a Katsukawa pupil he designed no actor prints. In the mid-1780s, like nearly every other artist in Edo, he was influenced by the elegant prints of Torii Kiyonaga (see Plate 19). As well as producing a large number of *chūban* and *ōban* format *bijin-ga*, often in triptychs, Shunchō was an outstanding designer of *hashira-e*.

18

Fishmonger and beauty
Colour print from woodblocks. *Hashira-e* on two sheets of paper joined, 667 × 117.
Signed: *Shunchō ga*. Publisher: *Iwa* (Iwatoya Kisaburō). Censor's seal: *kiwame*. 1790s.
Collector's seal: Wakai Kenzaburō (1834-1908).
Given by T. H. Riches 1913

From an untitled series of pillar prints designed by Shunchō for the publisher Iwatoya with poems above the figures' heads. The fishmonger is slicing the first bonito (*katsuo*) of the season in the fifth month. This time of year was primarily celebrated for the appearance of new greenery and the first call of the cuckoo (*cuculus poliocephalus*). Occasionally poets added the bonito to the list of seasonal delights, for example in a *hokku* by Sodō (1642-1716):

> *Fresh green for my eye in the mountains,*
> *the songs of the cuckoo for my ear,*
> *the first bonito for my tongue.*

The poem on this print puts the emphasis on the food:

> *Rather than the call of the cuckoo –*
> *Preparing this [bonito] cuisine.*

Torii KIYONAGA 1752-1815

Kiyonaga influenced most of his contemporaries profoundly and there was little work produced in the 1780s that did not fall under his spell, and this was especially true of *bijin-ga*. Kiyonaga was born either in Edo or Uragi, in Sagami Province. His earliest work dates from 1767 when he was a pupil of Torii Kiyomitsu (see Plate 4) who was then head of the Torii school. In 1775 Kiyonaga designed his first series of prints of women under the influence of Harunobu and Koryūsai. He succeeded Koryūsai in 1780 as the leading designer of female subjects, influencing a whole generation of younger artists, notably Utamaro and Shunchō. He was one of the first to design *ōban* format diptychs and triptychs, and the compositions of these, with figures spread across the sheets like a procession, became the standard arrangement over the next decade. His tall figures gradually became more elongated, a trend continued by his followers into the 1790s. Around 1787, he succeeded Kiyomitsu as head of the Torii school, and devoted himself almost entirely to work for the theatre and painting. From this time he designed fewer and fewer prints of women, and after 1790 produced hardly any prints at all.

19

Returning boats at the beginning of autumn
Risshū no kihan
Colour print from woodblocks. *Chūban*, 257 × 189.
Signed: *Kiyonaga ga*. Publisher: *Eijudō* (Nishimuraya Yohachi). *c.*1779.
Given by T. H. Riches 1913

From the set *Shiki hakkei* (Eight views of the four seasons) published by Nishimuraya *c.*1779. There are two prints for each of the four seasons. The titles relate to the eight traditional views of Lake Biwa in Ōmi Province (*Ōmi hakkei*), which in turn derived from the Chinese series 'Eight views on the Xiao and Xiang Rivers' (see p.15 above). The theme was later parodied in prints by applying the titles to other locations and everyday subjects. The equivalent title of this print in the Ōmi set is *Yabase kihan* (Returning sails at Yabase), which is depicted in the print reproduced as Plate 47. Harunobu designed a set in the mid-1760s showing women in everyday occupations, in which the equivalent print is entitled 'Returning sails of the towel rack'. In this print it is the boat that recalls the 'returning sails' title in the original set. A young boatman is stopping a boat with a bamboo pole to let two *geisha* embark. His purse is decorated with characters of the publisher's name.

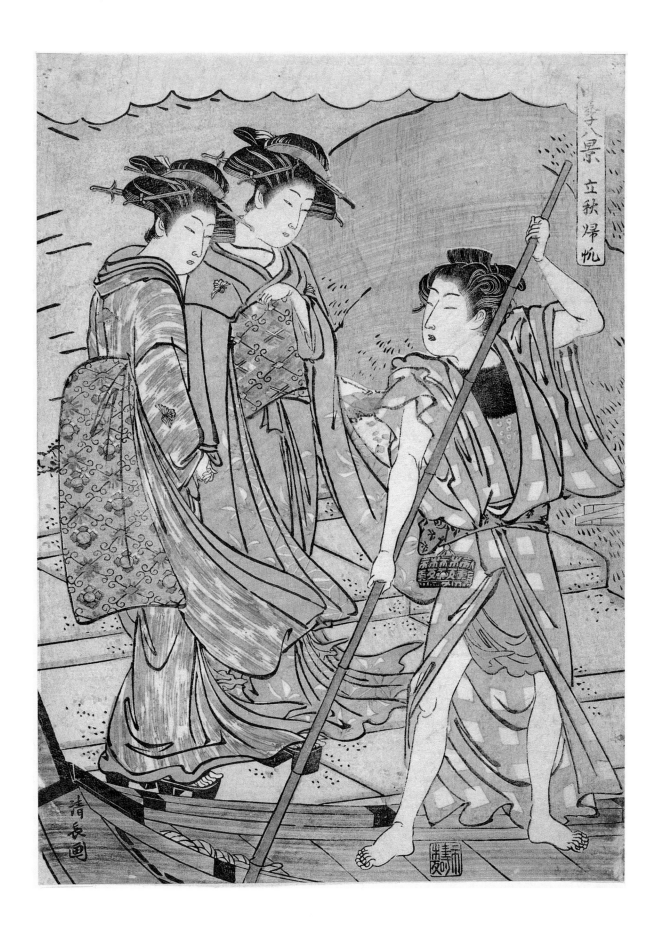

Torii KIYONAGA 1752-1815

20

Playing the *shakuhachi*
Colour print from woodblocks with blind
embossing (*karazuri*). Ōban, 380×257.
Signed: *Kiyonaga ga*. Publisher: *Eijudō* (Nishimuraya
Yohachi). *c*.1782.
Purchased from the Duplicate Objects Fund 1955
(P.12-1955)

This print depicts a woman and two youths dressed
as mendicant monks (*komusō*). *Komusō* monks
belonged to a branch of the Zen sect of Buddhism.
They did not shave their heads or observe
commandments, but wore a costume consisting of
a deep sedge hat (*tengai*) and a monk's stole (*kesa*);
around the time this print was made, high *geta* shoes
replaced straw sandals as their usual footwear.
Political refugees and spies, and a good number of
characters in *kabuki* plays, temporarily entered the
sect in the Edo period. The disguise gave them
anonymity and some freedom from the constraints
of the rigid codes of feudal society, as they wandered
the countryside begging alms. The great vogue in
prints for showing figures dressed in *komusō* costume
seems to have begun in the 1770s, with prints of
pairs of lovers, probably inspired by the dance
sequence 'Komusō' performed by the characters
Bunshichi and Seigawa in the play *Sono sugata shichi-
mai kishō* (Her lovely form: a seven-page written
pledge), produced at the Ichimura Theatre in 1770.

The woman in this print is playing the
shakuhachi, a curved flute made of bamboo with
four holes in the front and one in the back. It was
used for secular and religious music and was usually
carried and played by *komusō* monks in prints.
Around the same date as this print, the same
publisher issued a pillar print by Kiyonaga, showing
two young men dressed as *komusō*, one of them
carrying the *shakuhachi*, with an accompanying
poem:

> *Shakuhachi pieces*
> *have an insistent sound*
> *like the voice of a crane.*

Kitao MASANOBU 1761-1816

Masanobu was born in Edo. Poet, novelist, painter, print designer, and friend to most of the leading artists, writers and actors of the day, he epitomises the brilliant and witty *chōnin* of the Temmei era (1781–9). He was a pupil of Kitao Shigemasa (1739–1820), founder of the Kitao school, and began to illustrate books when he was only seventeen. Already in 1780 he was ranked third as an *ukiyo-e* artist behind only Shigemasa and Kiyonaga. His *kibyōshi* (humorous illustrated novelettes) published from the age of twenty were such a success that after 1785 he devoted most of his time to writing. Although he continued to design prints and illustrations until about 1805 he is best remembered today in Japan as a novelist under the name Santō Kyōden. Both his wives were Yoshiwara courtesans.

23
Komurasaki and Hanamurasaki of the Kado Tamaya house

Colour print from woodblocks with blind embossing (*karazuri*). Double *ōban*, 367 × 512. 1783–4.
Purchased from the S. G. Perceval Fund 1960 (P.69–1960)

One of two prints illustrated here made for the series *Seirō meikun jihitsu shū* (Samples of calligraphy by famous Yoshiwara courtesans) first advertised by the publisher Tsutaya Jūzaburō in 1783 with the intention that it would run to one hundred designs. In the event only seven prints appeared, and these were issued by Tsutaya for New Year 1784 as a sumptuous folding album entitled *Yoshiwara keisei shin bijin-awase jihitsu kagami* (Yoshiwara courtesans: a contest of new beauties, with samples of their own calligraphy as models), with a preface by the writer Ōta Nampo, and a postscript by the poet Akera Kankō (1740–1800). Each print depicts two of the most celebrated courtesans of the day in their lavish apartments, dressed in costly new spring outfits, with New Year poems in their own handwriting inscribed beside them. Here the courtesans watch as their apprentices unroll New Year brocade from the Nakaya store in the Tamachi section of the Yoshiwara. Both poems refer to the coming of spring.

24
Utagawa and Nanasato of the Yotsubaya house

Colour print from woodblocks with blind embossing (*karazuri*). Double *ōban*, 367 × 494. 1783–4.
Given by Mme E. Cuchet-Albaret 1958 (P.60–1958)

Another print from the same album as Plate 23. The depiction of leading Yoshiwara courtesans as figures of high culture was typical of prints produced in the 1780s, particularly in the publications of Tsutaya who had close links with the Yoshiwara.

The tall figure of the courtesan Nanasato holds a *tanzaku* (decorated poem slip) on which she is composing her poem; in her other hand she holds a brush, while her *shinzō* kneels beside her holding an inkstone ready. Associations with the courtly past are present in Nanasato's loosely worn long hair, which is reminiscent of Heian court fashions, while the decoration of her outer kimono consists of imitation *Genji mon* symbols associated with various chapters in *Genji monogatari* (The tale of Genji), together with famous scenes from two chapters of the novel: *Ukifune* (Boat upon the waters), in which Prince Niou and his lover Ukifune crossed the River Uji on a moonlit night after snowfall; and *Wakana jō* (New herbs, part one), in which Kashiwagi glimpsed the Third Princess and fell in love with her when her cat rushed onto the verandah. Nanasato's *hokku* is typical of the sort of poem that courtesans wrote to their clients, referring to the scent of a departed lover:

> *Though the raindrops gather,*
> *the scent of the plum lingers on.*

Utagawa is learning the words of a ballad to perform to the accompaniment of her *shamisen*, which is held by the *geisha* kneeling at her feet. Her poem compares the falling cherry blossoms of Yoshino with fluttering butterflies.

立吾妻角玉屋
筆乃うちを
名のくくを尋ねて
新玉乃
春と申らん
角川
鶯が

立吾妻角玉屋
之のとまる
おはすての
花それ
けしや
新吉
民か
豊那那花繁
志うらや
新吉景
古

23

24

Kitagawa UTAMARO *c*.1756-1806

25

Somenosuke of the Matsubaya house
Matsubaya uchi Somenosuke
Colour print from woodblocks. *Ōban*, 378 × 253.
Signed: *Utamaro hitsu*. Publisher: *Wakasaya Yoichi*.
1794.
Collector's seal: Hayashi Tadamasa (1854-1906).
Purchased from the S. G. Perceval Fund 1960
(P.70-1960)

Utamaro's teacher was Toriyama Sekien (1712-88), an artist of the Kanō school of painting who later designed illustrated books, the field in which Utamaro made his debut. In 1784 he took the name Kitagawa from the family name of the influential publisher Tsutaya Jūzaburō (1750-97), in whose house he lived for part of the 1780s. He established his reputation with illustrations to a series of *kibyōshi*, *kyōka* books and albums published by Tsutaya, who published nearly all of Utamaro's prints before his death in 1797. Tsutaya launched the young artist into the heady cultural world of merchants, bureaucrats, writers and artists who met in literary gatherings in the Yoshiwara. By 1783 he was a member of the 'Yoshiwara' *kyōka* group, and in that year he designed his first major *nishiki-e* series. In the 1780s his work was influenced by Masanobu and by Kiyonaga whom he succeeded as the leading designer of *ukiyo-e* prints after 1790. Shortly after 1790 he produced the first of his half-length portraits of women, followed quickly by the remarkable 'large heads' (*ōkubi-e*) of courtesans. Many of his subjects were taken from the brothels or tea-houses of the Yoshiwara – a larger proportion than in the work of any other leading artist.

From the series *Tōji zensei bijin-zoroe* (Array of supreme beauties of the present day) which shows Yoshiwara courtesans three-quarter length, disposed in daring designs against an intense yellow background. Ten designs are known, some of which were published with the word *nigao* (portrait) in the series title, before it was changed to *bijin* (beauty). The featured courtesans only coincide in the Yoshiwara guidebook (*Yoshiwara saiken*) in the spring of 1794.

This composition is the most remarkable of the series, and shows Somenosuke opening a love letter with a hairpin. The way she seems to press against the left edge of the print emphasises her attempt to open the letter without anyone noticing, and to keep its contents secret. The implied presence of another person, usually a client, outside the picture frame is common in Utamaro's prints. The artist was at the forefront of the experiments in the 1790s to explore the expressive potential of cropped images and 'close-up' heads (see Plate 26).

Like Kisegawa (Plate 26), Somenosuke was a courtesan of the highest *yobidashi* rank in the brothel of Matsubaya Hanzaemon, situated on the right corner of the street Edo-chō 1 chōme approached from the central Nakanochō boulevard in the Yoshiwara. Utamaro designed another print of her, full-length with a *kamuro*, at around the same time as this series, and about two years later he portrayed her again in a bust portrait. Her *kamuro* are named on this print as Wakagi and Wakaba.

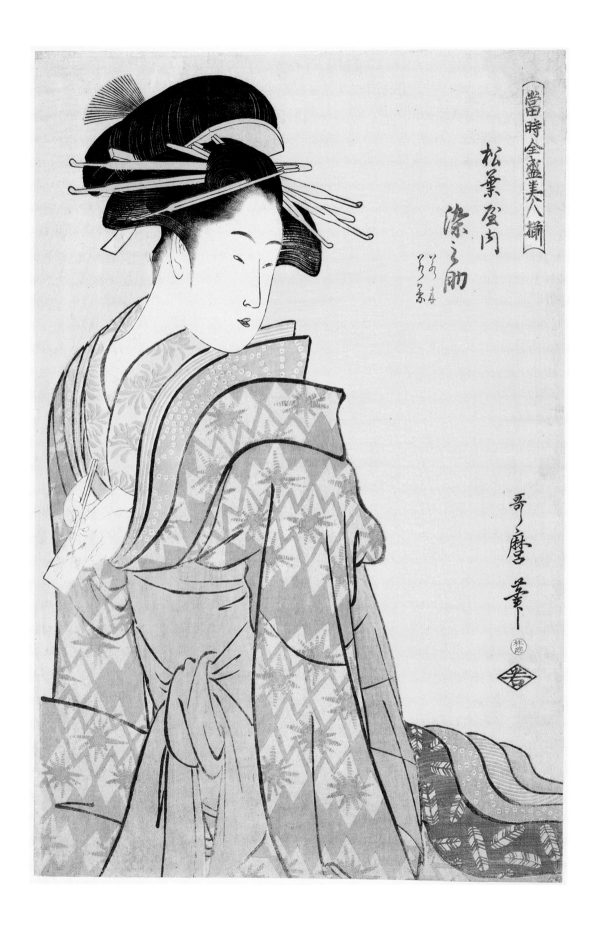

Kitagawa UTAMARO *c.*1756–1806

26
Kisegawa of the Matsubaya house
Matsubaya uchi Kisegawa
Colour print from woodblocks. *Ōban*, 387 × 253.
Signed: *Shōmei* (genuine) *Utamaro hitsu*. Publisher:
*Sen-Sa. c.*1794–5
Oscar Raphael Bequest 1941 (P.200-1946)

From the series *Seirō nana Komachi* (Seven Komachis of Yoshiwara), a title referring to the seven famous episodes in the life of the Heian-period poet Ono no Komachi (see Plate 33) that were often parodied and brought up to date in prints. However, these seven 'large-head' portraits of leading Yoshiwara courtesans do not provide specific references to scenes from the poet's life. The intention rather was to imply 'seven beauties' by association with Komachi, who was famed for her looks as well as her poetry. The prints were issued first with a yellow background, and then, slightly later, with a grey background, as in this impression.

As with the series *Tōji zensei bijin-zoroe* (Array of supreme beauties of the present day; see Plate 25), the courtesans and *kamuro* in this series coincide in the Yoshiwara guidebook only in spring of 1794. Kisegawa was the name of the highest-ranking *yobidashi* courtesan in the brothel of Matsubaya Hanzaemon in the first half of the 1790s. She retired soon after the spring of 1794. As she is shown with her hair down in the manner worn for the *tsukidashi* ceremony (the launching of a new courtesan), it is possible that the print shows her successor, who inherited the name Kisegawa. However, the *kamuro* named on this print, Sasano and Takeno, belonged to the first Kisegawa and did not serve the second, who was not 'launched' until the following year. Although there may be other explanations, it seems probable that the print shows the first Kisegawa and that there is another reason for the way she wears her hair. It may be significant that the print by Masanobu (Plate 24) shows a high-ranking courtesan with her hair worn loose in a very similar way. Masanobu's figure recalls poetesses of the Heian court, so perhaps Utamaro is making a veiled visual reference to Komachi, which otherwise seems lacking from the series. Kisegawa appears again in Act 7 of the *Kanadehon chūshingura* series (Plate 27).

The 'large-head' format focuses attention on the physiognomy (*sōgaku* or *sōhō*). Although Utamaro's portraits may seem generalised, they were obviously intended to fascinate an audience who employed professional physiognomists (*sōmi*) to read character. In one series, 'Ten types in the physiognomic study of women', Utamaro signed himself 'Utamaro the physiognomist'.

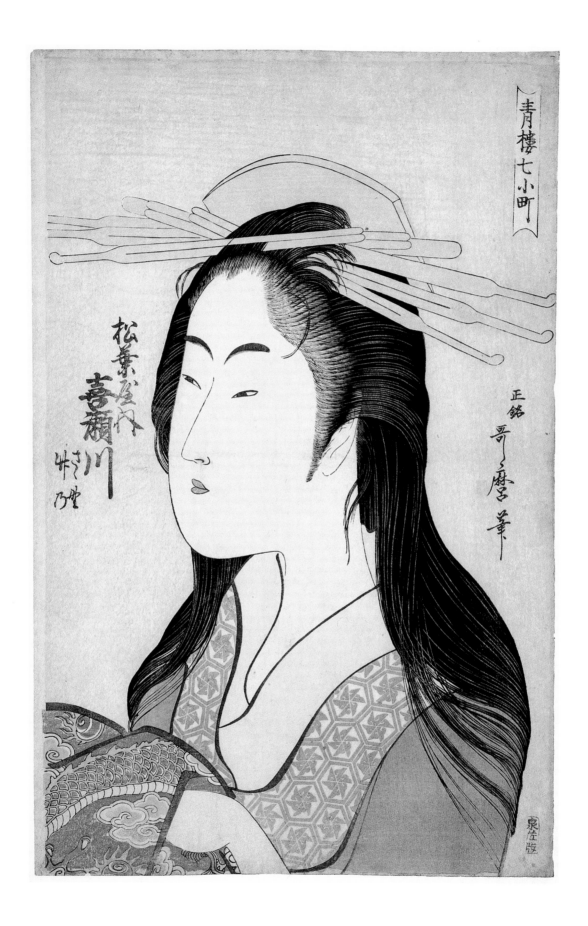

Kitagawa UTAMARO *c.*1756-1806

27

The *Chūshingura* drama parodied by famous beauties: a set of twelve prints

Kōmei bijin mitate Chūshingura junimai tsuzuki

Folding album with silk covers containing the set of 12 woodblock *ōban* prints, each sheet *c.*387 × 257. Signed (each sheet): *Utamaro hitsu.* Publisher: Ōmiya Gonkurō. *c.*1795

Given by the Friends of the Fitzwilliam 1945 (P.348-59-1945)

This unique album containing the only known complete surviving set of this series formerly belonged to Edmond de Goncourt (1822-96), who published the first book about Utamaro in 1891. His manuscript note is pasted on the inside cover stating that he bought it for 175 francs as a work of the greatest rarity from the Paris dealer Hayashi Tadamasa in 1885.

Kanadehon chūshingura (Model for *kana* calligraphy: treasury of the forty-seven loyal retainers) is the most famous of the *kabuki* revenge plays and is frequently illustrated in prints. Utamaro made several *mitate* (parody) sets of the story. In this series, scenes from the play are represented as scenes in the life of celebrated contemporary beauties – courtesans, *geisha* and tea-house waitresses – thus creating humorous comparisons between their petty squabbles and the ferocious action of the original. All the prints, except the first and last (a diptych), are inscribed with the names of the women or the houses where they worked. The set was later reissued with the names removed probably in response to the decree of 1796 reinforcing an earlier ban on the appearance of women's names other than courtesans.

The play was first written in eleven acts for the puppet theatre in 1748 by Takeda Izumo, Miyoshi Shōraku and Namiki Sōsuke, but was quickly adapted for the *kabuki* stage. The action was based on historical events that took place in 1702-3, although in accordance with theatrical convention the play moved the events back to the fourteenth century. Lord Enya is goaded by the villain Moronao into the offence of drawing his sword within the castle precincts. Enya is ordered to commit *seppuku* (honourable suicide) and his loyal retainers are dismissed to become *rōnin* (masterless warriors). They resolve to avenge their master's death under the leadership of Yuranosuke. They eventually attack Moronao's castle, and after he refuses the chance to commit ritual suicide, Yuranosuke kills him, and they place his head on Enya's grave.

ACT I

The *geisha* Tomimoto Toyohina, who has just performed on the *shamisen* before a young lord, receives a cup of *sake* and the gift of a robe. This parodies the scene at the Hachiman Temple in which the lecherous villain Moronao tries to insinuate himself with Enya's wife, Lady Kaoyo, and hands her a love letter. Toyohina represents Kaoyo. The maid holding the robe represents Moronao.

ACT 2

Oseya, a waitress from the Hiranoya tea-house, is cutting a spray of Japonica to arrange in the vase on the verandah, watched by the *geisha* Tomimoto Itsutomi. This parodies the scene in which the loyal retainer Honzō hacks off a pine branch with his sword to demonstrate to his master, Lord Wakanosuke the manner in which they should deal with Moronao.

ACT 3

A letter that has come for the waitress Takashima Ohisa (on the left) has angered a woman from the 'Hishiya' into attacking her with a rolled-up towel; Osei, a waitress at the Fukuju tea-house tries to intervene. This parodies the scene in which Moronao goads Enya into attacking him with his sword in the castle precincts, and Honzō, fearing the consequences, intervenes to restrain Enya.

ACT 4

Hanaōgi (centre), the famous courtesan from the exclusive Ōgiya house, admires flower arrangements with her *kamuro* (right) and Daizaburō, who may be a male prostitute in feminine attire (*kagema*). This parodies the scene in which Ōboshi Rikiya presents Kaoyo with a basket of flowers in condolence after Enya's ritual suicide (*seppuku*).

ACT 5

The older woman Okinu, who is washing clothes, hands an amulet-bag to Okita, the beautiful waitress from the Naniwaya tea-house. This parodies the scene on the Yamazaki highway in which the robber Ono Sadakurō murders the old man Yoichibei and steals his purse. Okita's black raincoat and umbrella recall Sadakurō's obligatory costume, while the *bonsai* pine recalls the trees along the highway.

ACT 6

A woman from the Suminoe tea-house attends to her hair, while Ohan, a waitress from the Kikumoto tea-house, shows her a list of the tea-houses that employed beautiful women; a woman from the Odawara looks on. This parodies the scene in Yoichibei's house in which Goemon shows the dying Kampei a scroll listing the forty-seven *rōnin*, so that he can seal it with his blood. Yoichibei's wife, who has provoked Kampei's needless suicide, looks on.

ACT 7

The courtesan Kisegawa (see Plate 26) sits on the balcony adjusting her make-up in a mirror, while a man, probably a male prostitute (*kagema*) reads a letter. This is a close representation of the famous scene at the Ichiriki tea-house in which Yuranosuke reads a letter from Kaoyo, spied on simultaneously by the courtesan Okaru using a mirror on the balcony above, and Moronao's spy Kudayu, who reads the bottom of the letter from his hiding place beneath the verandah.

ACT 8

The *geisha* Hama-chō Rokō and the influential *onnagata* Iwai Hanshirō IV, on a pilgrimage to Enoshima, near Kamakura. This parodies the *michiyuki* scene in which Honzō's wife and daughter, Tonase and Konami, travel to Yamashina in Kyoto in order to settle Konami's marriage. Konami wonders whether her happiness will vanish like snow-dust on Mount Fuji, seen here in the background.

ACT 9

A woman feels the sharpness of a razor before shaving the nape of the seated Kurataya Yū. At the front is Tokusaburō holding a deep sedge hat above his head, the gesture of a male prostitute (*kagema*). This parodies the scene in which Tonase is about to kill her daughter Konami with Honzō's sword in a pact of ritual suicide, only to be stopped by the arrival of Honzō disguised as a *komusō* monk (see Plate 20).

ACT 10

In preparation for a banquet to be held at the Shōtōan tea-house (*Shōtō* is the name on the lantern), a woman from the Ebisuya house has climbed on top of a trunk in order to take boxes containing china from a high shelf (the boxes have labels such as *large dish from Nanking*). This parodies the scene in which the merchant Gihei, who has secretly been shipping arms to the *rōnin*, refuses to give away their plans and jumps onto a trunk in order to keep its contents from the police.

ACT 11

The concluding diptych shows a riotous party in a brothel at night. On the right three women play a kind of hand-game (stone, paper, scissors), the forfeit for which is to drink *sake* from the cup placed between them. On the left we discover Utamaro himself, being handed a larger ceremonial *sake* cup by a courtesan. On his jacket are the characters *Uta* and *maro*, and the inscription on the pillar above his head reads: *By request Utamaro draws his own ravishing features* (the lantern is inscribed with the character *chū* (loyalty) from the play's title). This parodies the climactic night scene in which the *rōnin* raid Moronao's castle and discover the villain hiding in the wood-shed; Yuranosuke hands him Enya's dagger so that he can commit suicide.

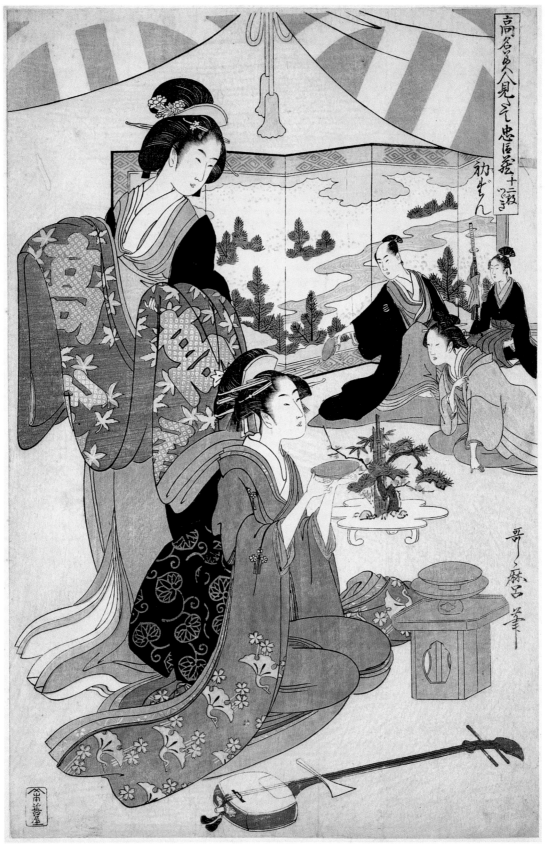

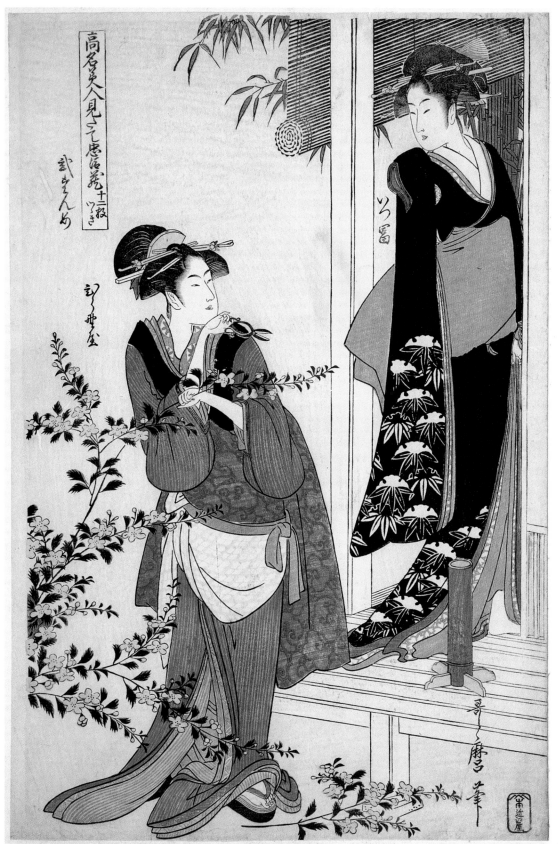

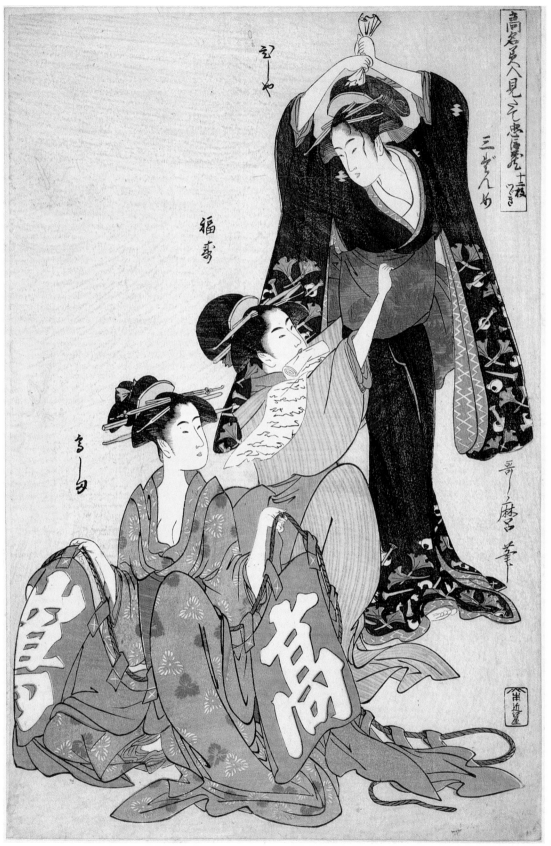

ACT 4

ACT 6

ACT 8

Hosoda EISHI 1756-1829

Eishi was born into a high-ranking family and studied with the painter Kanō Eisen'in Michinobu (1730-90). He served the *shōgun* Ieharu as 'painting companion', before adopting the popular *ukiyo-e* style around 1785. His elegant prints retained something of the refined sensibilities of *samurai* art. Around 1800 he stopped designing prints and devoted himself to painting.

28

The Sumiyoshi dance
Colour print from woodblocks. *Ōban* triptych, each sheet 354×234/242.
Signed: *Eishi ga* (central sheet). Publisher: *Eiju han* (Nishimuraya Yohachi). Censor's seal: *kiwame. c.*1791.
Purchased from the S. G. Perceval Fund 1960
(P.68-1960)

Triptych prints first appeared in the 1720s in the narrow *hosoban* format with one figure per sheet. By the mid-1780s artists such as Eishi and Kiyonaga had developed the format into a medium for complex multi-figure compositions across three *ōban* sheets. This example still reveals Eishi's stylistic debt to Kiyonaga before he developed more elongated figures in the mid-1790s (see frontispiece).

The Sumiyoshi dance (*odori*) originated at Sumiyoshi Shrine, in Settsu Province, as part of the ceremony to bless the annual transplanting of the rice crop (*otaue*), but it later became popular at shrines throughout the country. The dance was performed in the street around a large festival umbrella (*kasaboko*) with a red cloth fringe and paper strips (*gohei*) hanging from the top. Performers dressed in red aprons, umbrella-shaped hats, carried round fans (*uchiwa*), and made a whipping sound with sticks of split bamboo. Local courtesans and waitresses may have performed the dance, but Eishi's elegant print is far removed from the illustrations of the dance in contemporary book illustrations. It is essentially a *mitate* version, with tea-house waitresses shown without the usual hats that would have obscured their elaborate coiffures and beautiful faces.

Utagawa TOYOKUNI 1769-1825

Toyokuni was a pupil of Utagawa Toyoharu, founder of the Utagawa school. His early work consisted mainly of pictures of beauties, in a style influenced first by Kiyonaga and then by Utamaro, but it was in the field of theatrical prints that he established his own predominance. His pupils included Kunisada and Kuniyoshi (see Plates 51-7).

29

Picture of a theatrical performance by maids at year's end

Toshi-wasure jochū kyōgen no zu

Colour print from woodblocks. *Ōban* triptych, each sheet 378 × 253.

Signed: *Toyokuni ga*. Publisher's mark: *Izumiya Ichibei*. *c*.1800.

Given by the Friends of the Fitzwilliam 1961 (P.126-1961)

Women in a *samurai* mansion are preparing for a New Year theatrical performance with musical accompaniment. The popularity of *kabuki* resulted in an enthusiasm for amateur performances at home. Instruction books were published, and special shops provided the necessary costumes and props. In many households it was the custom to invite a female dance teacher (*o-kyōgen shi*) of the *chōnin* class to give performances for the entertainment of the daughter of the lord and her female attendants. These teachers would also instruct the female attendants and supervise performances of the dance interludes they had learned.

On the right, the young mistress of the household is visible, waiting discretely behind a folding screen with reed blinds. In the foreground, performers are preparing musical instruments and props. Costumes for the performance are hanging on the left, and a large cherry tree is painted on the stage curtain in the central background. The emphasis on diagonal lines of recession to establish a picture space shows the influence of Toyokuni's teacher, Toyoharu, who was a leading designer of pictures based on European systems of vanishing-point perspective, known as *uki-e* (floating views).

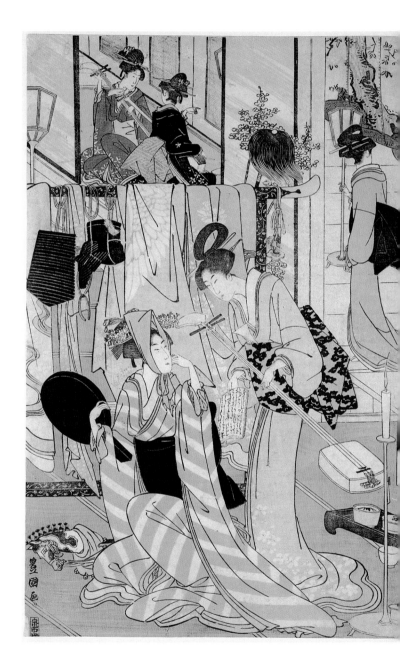

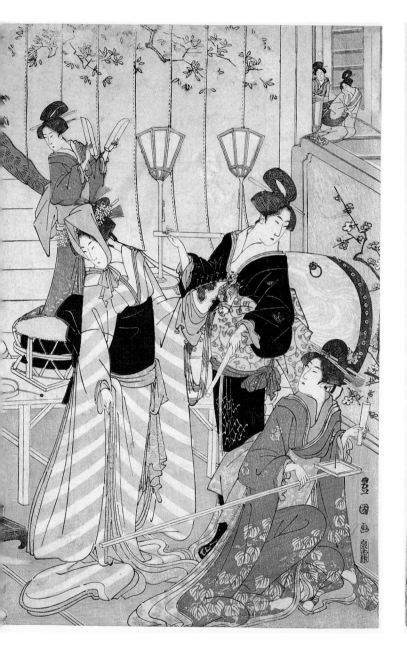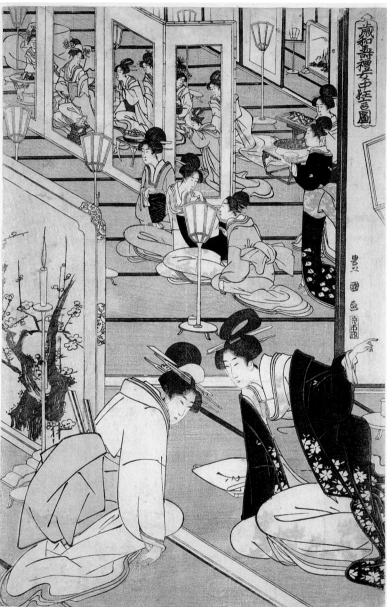

Utagawa TOYOHIRO 1763/73-1829

Toyohiro was a fellow pupil with Toyokuni of
Utagawa Toyoharu, whose studio he entered about
1782. His early work was similar to that of Toyokuni
but he developed a more fragile figure style and his
compositions generally have a more restrained,
courtly air. He designed a calendar print as early
1788, but his datable prints are rare until the late
1790s. Thereafter he designed a large number of
book illustrations and a small number of prints of
beauties and landscapes, the latter clearly influenced
by Toyoharu. His work in landscape must have been
a formative influence on his pupil, Hiroshige (see
Plates 42-50, 58-9).

30
Hunting party
Colour print from woodblocks. *Ōban* triptych,
each sheet 370×240/250.
Signed: *Toyohiro ga*. Publisher: *Matsuyasu*. Late 1790s.
Marlay Bequest 1912

In this print a noble youth on horseback is
accompanied by six female attendants dressed in
male hunting costume. It is no doubt intended as a
mitate (parody) of a hunting expedition.
Recreational hunting, which had once been a
symbol and expression of *samurai* vigour and part of
bushidō (the way of the warrior), had declined by the
early eighteenth century as *samurai* turned their
attention to the expensive pursuit of pleasure in
Edo. Nevertheless, hunting with birds of prey
remained a *samurai* privilege and the representation
of a falcon on the hand was often used to denote a
daimyō or other leading member of the *samurai* class
(see Plate 53).

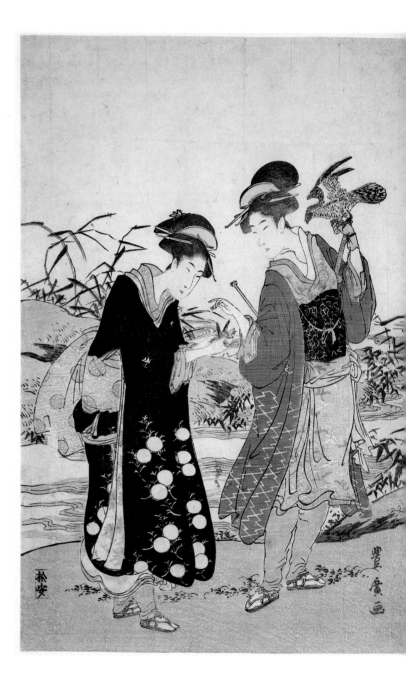

Kitagawa UTAMARO *c.*1756-1806

31
A child's nightmare of ghosts
Bakemono no yume
Colour print from woodblocks. *Ōban*, 380 × 251.
Signed: *Utamaro hitsu*. Publisher: *Ōmiya Gonkurō*.
*c.*1800–1
Given by T. H. Riches 1913

A young boy sleeping inside his own mosquito
net has woken screaming from a nightmare, and
his mother has put down her sewing in order to
comfort him. The ghosts in his dream are shown in
a cartoon-like bubble. They include a long-necked
monster (*rokuro-kubi*) and a one-eyed temple page
(*hikotsu-me kozō*) who carry on the following
conversation:

> *'Let's give him some more nightmares tonight.'*
> *'As long as his mother doesn't wake him we'll scare*
> *him some more.'*
> *'Right, let's show his mother some horrid dreams*
> *tonight as well!'*

This print combines the traditional category of
bakemono-e (demon pictures), with the type of
mother-and-child picture that Utamaro designed in
considerable number for the publishers Ōmiya
Gonkurō and Izumiya Ichibei in the early 1800s.
Bakemono-e first appeared as an independent type in
the *egoyomi* of Harunobu, and later became a
speciality of Utamaro's teacher, Toriyama Sekien.
Ōmiya issued two other prints by Utamaro with
similar subjects, one of them called *Chōji no yume*
(The infant's dream). One of the reasons why
Utamaro and his publishers turned to domestic
scenes outside the Yoshiwara in these years may have
been the censorship ordinance of 1800 banning
'large-head' prints, and the earlier bans that
prevented the naming of celebrated beauties
such as *geisha* and tea-house waitresses.

32

33

32
Kisen Hōshi
Colour print from woodblocks, with fabric-printing
(*nunome-zuri*). Ōban, 371 × 263.
Signed: *Katsushika Hokusai ga. c.*1810.
Given by the Friends of the Fitzwilliam 1941
(P.318-1941)

33
Ono no Komachi
Colour print from woodblocks. Ōban, 374 × 258.
Signed: *Katsushika Hokusai ga. c.*1810.
Given by the Friends of the Fitzwilliam 1941
(P.320-1941)

Born in the Honjo district of Edo, Hokusai was
apprenticed to a woodblock-cutter in 1775. He
entered the studio of Shunshō in 1778 and designed
a number of actor prints in the Katsukawa style.
From the 1790s he designed numerous *surimono* and
kyōka album pages, signing them first *Shunrō*, and
then *Sōri*. In 1797 he announced his change of
artist's name to Hokusai and began designing
Western-style prints and albums of Edo views.
The first volume of *Hokusai manga*, an album of
miscellaneous sketches that significantly shaped
the European view of Japanese art in the later
nineteenth century, appeared in 1814. After
returning to *surimono* (Fig.4) in the 1820s, he
embarked on the numerous series of *ōban* landscape
views for which he is best remembered. With the
economic crisis of the Tempō era (1830-44) he was
reduced to penury in the years 1836-8, and
thereafter concentrated largely on painting.

From the series of six prints entitled *Rokkasen* (The
six immortal poets), published by Ezakiya Kichibei
around 1810. The outlines of each figure in
Hokusai's set are formed by the cursive renderings
of the Chinese characters representing the poet's
names, a device borrowed from Chinese and
Japanese painting. The calligraphy of the poems is by
Kokunan. The background of this impression of
Kisen Hōshi is embossed with the pattern of a woven
fabric. It is the only print in the Fitzwilliam's set
with fabric-printing (*nunome-zuri*). The colours of
the set are very well preserved.

The Six Immortal Poets of the early Heian
period were first grouped together and critically
appraised by Ki no Tsurayuki (see Plate 10) in the
preface to the early tenth-century Imperial
anthology *Kokin wakashū* (Collection of poems past
and present). Although in several cases little is
known about the poets, they were so revered by
later generations as archetypal classical models that
legends grew around them, and these were
assimilated into popular culture in paintings, prints
and plays. All but one of the poets also appeared in
the thirteenth-century anthology that formed the
basis of Hokusai's series *Hyakunin isshu uba ga etoki*
(One hundred poems by one hundred poets as
explained by a nurse; see Plates 38-40). The poet
Kisen was a priest (*hōshi*) who lived in the early
ninth century as a recluse in the mountains near
Uji, south-east of Kyoto. Uji-yama is today known
as Mount Kisen (*Kisen-dake*). Kisen is known only
for the poem on this print:

> *My lowly hut lies south-east from the capital –*
> *thus I choose to dwell*
> *with the lonely cry of the stag,*
> *and my world has been called*
> *a Mountain of Sorrow.*

From the series *Rokkasen* (The six immortal poets),
published by Ezakiya Kichibei around 1810. Ono no
Komachi (834-80) was the daughter of the governor
of Dewa Province, and the adopted daughter of the
poet Ono no Takamura. She was renowned for her
beauty and wit as well as her poetry. Seven scenes
from Komachi's life were made famous in *nō* plays
written in the fourteenth century, and these were
later adapted in *kabuki* and depicted in prints (see
Plate 26). Hokusai designed a series of *surimono*
illustrating the seven episodes.

The Chinese characters (*kanji*) for the first part
of the poet's name are formed by the outline of her
figure, with the character for the last part of her
name, *machi*, appearing as the T-shaped *kichō* screen
on the right.

Komachi's poem reads:

> *That which fades away*
> *without revealing its altered colour*
> *is, in the world of love,*
> *the single flower that blossoms*
> *in the fickle heart of man.*

34

South wind – clear dawn
Gaifū kaisei
Colour print from woodblocks. *Ōban*, 253 × 377.
Signed: *Hokusai aratame Iitsu hitsu. c.*1830–1.
Given by T. H. Riches 1913

35

Sudden storm below the summit
Sanka haku-u
Colour print from woodblocks. *Ōban*, 262 × 383.
Signed: *Hokusai aratame Iitsu hitsu. c.*1830–1.
Oscar Raphael Bequest 1941 (P.190-1946)

From the series *Fugaku sanjū-rokkei* (Thirty-six views of Mount Fuji), published by Nishimuraya Yohachi *c.*1830–2. It was the first major series of large-scale (*ōban*) landscapes in the history of Japanese print production. In New Year 1831, soon after the first designs had been published, Nishimuraya advertised that the series was to be printed in *aizuri* technique, with the predominant use of Prussian blue (*berorin-ai*), an expensive and rare European pigment only recently introduced into Edo. He indicated that the series 'will likely exceed a hundred scenes – not just limited to thirty-six'. In fact forty-six designs were published, with the extra ten prints (and also later printings of the earlier designs) reverting to the use of colours other than Prussian blue, including the more traditional use of black for the outline-block. Nevertheless, the new pigment must have contributed to the feeling of novelty and daring that made the series a success. Its popularity with the public led to the flurry of major landscape series by Hokusai and Hiroshige in the 1830s.

Mount Fuji is a volcano 3,776 metres above sea level and visible on clear days from Edo (Tokyo) sixty miles away. According to tradition Fuji was thrown up in a massive earth upheaval in 286 BC. Regarded as the seat of the Shintō gods and dotted with temples, its significance and exceptional natural beauty attracted pilgrims, poets and artists over many centuries (see Plates 11, 16, 59 and 27 Act 8). Hokusai's series capitalised on the Fuji-worship current in Edo. The *Fuji-kō* cult grew in the second half of the eighteenth century and by the 1830s flourished among townsmen and villagers. The mountain was opened to climbers each year on the first day of the sixth month, and roads leading to the two starting points for the climb were crowded from the preceding day. More than sixty miniature 'Mount Fujis' were built in and around Edo, and these were also jammed with pilgrims.

This print shows the mountain in late summer or early autumn when it appears pink at dawn. It is commonly known in Japan as 'red Fuji' (*aka-Fuji*), partly due perhaps to the stronger red in some impressions. The appearance of the mountain as viewed at dawn from the Lake Kawaguchi region is called locally 'rose-red Fuji' (*beni-Fuji*), which more accurately describes the colour in early impressions such as this. The hue of the mountain, modulated by subtly graded shading (*bokashi*) and clearly showing the grain of the woodblock, contrasts with the intense Prussian blue of the sky and trees. The clouds, unprecedented in Japanese art, probably derived from Hokusai's observation of European copperplate prints. He included a similar view in the fifth volume of his picture book *Hokusai manga* (1816), and used the idea again in volume one of *Fugaku hyakkei* (One hundred views of Mount Fuji) published in 1834. This print and the complementary stormy view (Plate 35) were among the first group in the series to appear in 1831. They are unusual, not only in the series but in the whole of Hokusai's work, in their exclusion of any human presence or incidental detail.

From the series *Fugaku sanjū-rokkei* (Thirty-six views of Mount Fuji), published by Nishimuraya Yohachi, *c.*1830–2. Hokusai also included a view of Fuji with lightning in volume two of *Fugaku hyakkei* (One hundred views of Mount Fuji) published in 1835.

34

36

Katsushika HOKUSAI 1760-1849

38
Sarumaru Dayū
Colour print from woodblocks. *Ōban*, 257 × 375.
Signed: *zen Hokusai*. Publisher: *Eijudō* (Nishimuraya
Yohachi). Censor's seal: *kiwame. c.*1835.
Given by the Friends of the Fitzwilliam 1941
(P.325-1941)

No. 5 in the series *Hyakunin isshu uba ga etoki* (One
hundred poems by one hundred poets as explained
by a nurse), Hokusai's last series of prints, begun in
his seventy-sixth year. The first five prints in the
series were published by Nishimuraya Yohachi, the
remainder probably by Iseya Sanjirō around 1835-6
after Nishimuraya went bankrupt. Only twenty-
seven prints were finished, but Hokusai's preparatory
drawings (*hanshita-e*) for over sixty more subjects are
known (see Fig. 6). Nishimuraya's bankruptcy
resulted from the Tempō crisis in the mid-1830s,
caused by bad harvests blamed on corrupt
administration. About 100,000 people died of
starvation and there were peasant uprisings in
numerous Provinces. Many inhabitants of Edo,
including Hokusai, fled to the countryside. Cultural
life in the capital came to a standstill, and many
serial publications, such as this series and Hokusai's
Fugaku hyakkei (One hundred views of Fuji), were
interrupted or abandoned.

The poems come from perhaps the most popular
classical poetry anthology, compiled in 1235 by
Fujiwara no Teika (1162-1241) and entitled
Hyakunin isshu ('one hundred people, one poem
each'). This was known to every educated Japanese
of the Edo period through a card game played at
New Year that involved matching the two halves of
each of the hundred poems. In Hokusai's title, the
word *uba* can signify either an old woman, or a
woman hired by a family as a wet-nurse. It has been
suggested that he intended to characterise the
poems as interpreted by a country woman who sees
the world without the subtleties of courtly life,
although many of the interpretations seem to show
the influence of courtly refinement. Most of the
designs have a timeless poetry to them, and reveal
the influence of classical Chinese painting, in
contrast to the modernity of some of the 'Thirty-six

views of Mount Fuji' (Plates 34-5). The numbering
follows that of the original anthology.

This print illustrates the poem by the eighth-
century writer Sarumaru Dayū who lived in the
mountains near Kyoto:

In the mountain depths,
treading through the crimson leaves,
cries the wandering stag.
When I hear the lonely cry,
sad – how sad – the autumn is!

Women are returning home to their mountain
village at sunset, probably after gathering leaves with
their rakes and baskets. Two of them stop to listen,
and one points with her hand to the distant deer on
the hilltop. The mating cry of the stag was often
used in poetry as an evocation of melancholy and of
a lover's yearning.

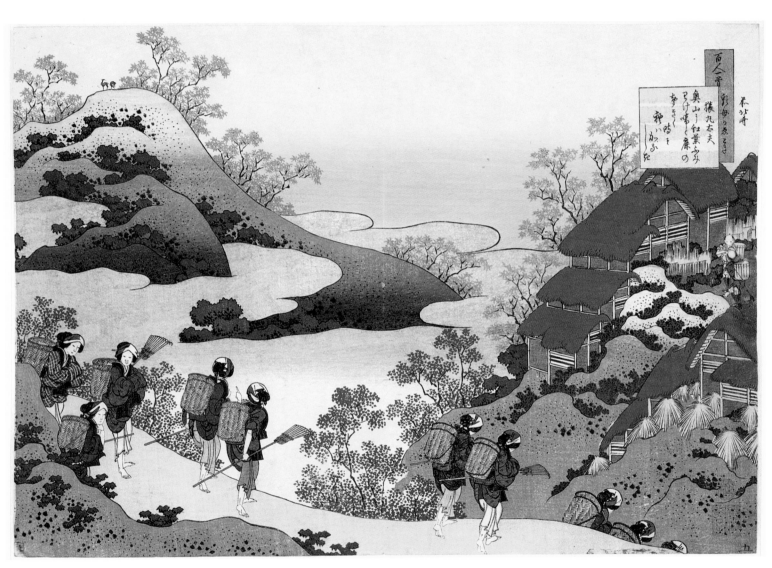

38

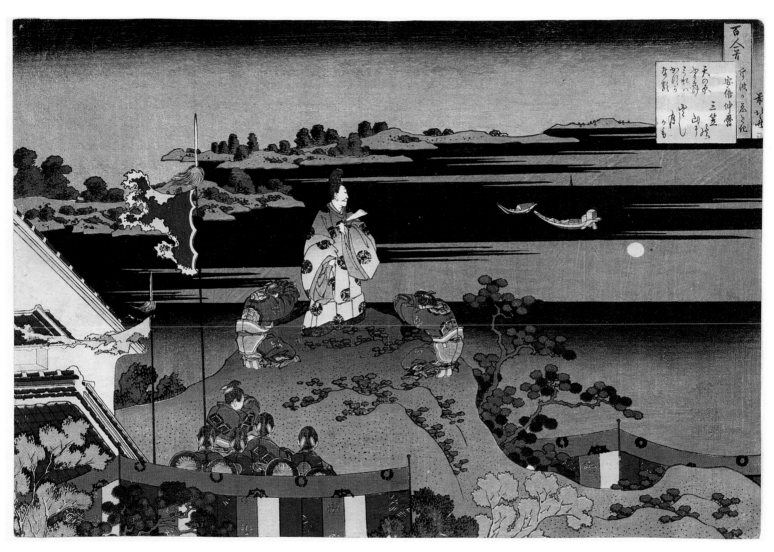

39

39

Abe no Nakamaro

Colour print from woodblocks. *Ōban*, 245 × 367.
Signed: *zen Hokusai Manji*. Publisher: *Eijudō*.
(Nishimuraya Yohachi). Censor's seal: *kiwame*. *c*.1835.
Given by T. H. Riches 1913

No.7 in the series *Hyakunin isshu uba ga etoki*
(One hundred poems by one hundred poets as
explained by a nurse).

The Japanese nobleman and poet Abe no
Nakamaro (*c*.700–70) went to China to study in
717 and remained there until his death. According
to legend he went to discover the secrets of the
Chinese calendar. The Chinese emperor learned of
this, and invited him to a formal dinner on the roof
of a high pagoda. During the meal, the emperor and
his retinue departed, pulling away the ladder so that
Nakamaro would be left to starve to death. At this
moment, Nakamaro looked eastwards and saw the
rising moon, which reminded him of the moonrise
over the hill of Mikasa in his native Nara. He bit his
hand and wrote down this poem in his own blood:

> *When I look abroad*
> *o'er the wide-stretched 'Plain of Heaven',*
> *is the moon the same*
> *that I used to see rising over*
> *Mount Mikasa in the land of Kasuga?*

It was the custom for envoys to pray at Kasuga
Shrine, near Mount Mikasa, before leaving for
China. In both China and Japan, the moon
traditionally evokes memories of the past.

In another version of the story Nakamaro was
prevented from returning home by a fierce wind,
which seems to blow in this print, and it may be this
other version that Hokusai had in mind. It is also
unusual for the poet to be standing on the top of a
hill rather than on top of a pagoda (he was shown
on a pagoda by Hokusai on other occasions). A
preparatory drawing shows that Hokusai initially
intended the moon to appear only in the sky; the
print improves on this by daring to show only the
reflection.

40

Minamoto no Muneyuki Ason

Colour print from woodblocks. *Ōban*, 255 × 375.
Signed: *zen Hokusai Manji*. Publisher: *Eijudō*
(Nishimuraya Yohachi). Censor's seal: *kiwame*. *c*.1835.
Given by T. H. Riches 1913

No.28 in the series *Hyakunin isshu uba ga etoki* (One
hundred poems by one hundred poets as explained
by a nurse).

The poem is by Minamoto no Muneyuki (died
939), a grandson of the emperor Kōkō:

> *Winter loneliness in a mountain hamlet*
> *grows only deeper*
> *when guests are gone,*
> *and leaves and grass are withered –*
> *so runs my thought.*

Hunters warm themselves at a fire. The warmth of
their temporary blaze contrasts with the hut on the
right, abandoned to the snow.

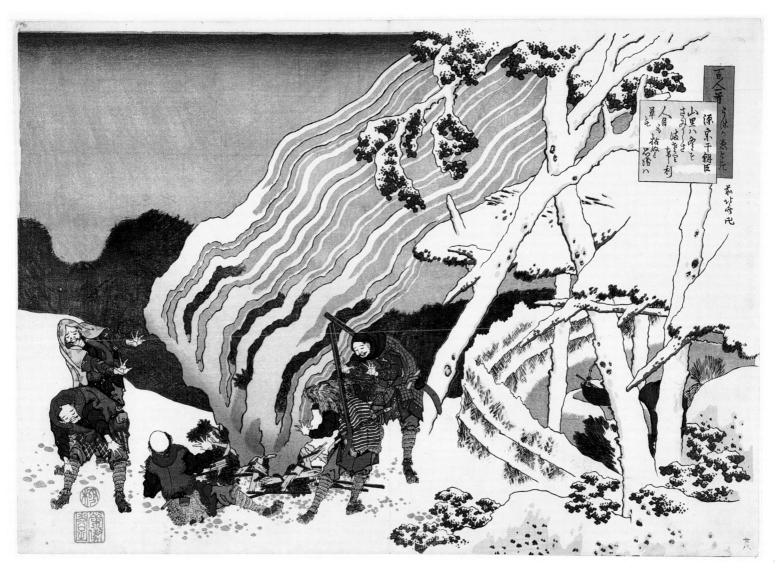

40

Katsushika HOKUSAI 1760-1849

41
Irises and grasshopper
Colour print from woodblocks. *Ōban*, 258 × 379.
Signed: *zen Hokusai Iitsu hitsu*. Publisher: *Eijudō*
(Nishimuraya Yohachi). Censor's seal: *kiwame*.
*c.*1833-4.
Oscar Raphael Bequest 1941 (P.191-1946)

From the rare untitled series of flower prints
published by Nishimuraya Yohachi *c.*1833-4 known
as the 'Large flowers'. The series is remarkable not
only for the careful observation of nature and the
realism of the depiction, but also for the bold, close-
up compositions, which might be considered the
equivalent of 'large-head' close-ups (*ōkubi-e*) applied
to landscape. Hokusai followed up this series with a
series in smaller (*chūban*) format, known as the
'Small flowers'. Around the same time, Hiroshige
made his first *kachō-e* (bird and flower pictures)
which, together with Hokusai's flowers, belong to a
larger category, *kachō-fūgetsu* (flower and bird, wind
and moon), a term used to describe the beauty of
the natural world as a whole. The importance that
Hokusai attached to the study of nature can be
gauged from the artist's own postscript to the first
volume of *Fugaku hyakkei* (One hundred views of
Mount Fuji) published in 1834:

> Ever since the age of six I have had a mania
> for drawing all kinds of things. Although I had
> published numerous designs by my fiftieth
> year, none of my works produced before my
> seventieth year [1830] is really worth
> considering. At the age of seventy-three I have
> almost come to understand the true form of
> animals, insects and fish, and the real nature of
> plants and trees. Consequently, by the age of
> eighty I will have made more progress; at ninety
> I will have got closer to the essence of art; at the
> age of one hundred I will have reached a
> decidedly higher level which I cannot define,
> and at one hundred and ten each dot and each
> line from my brush will be alive.

The iris was traditionally associated with festivals
held early in the fifth month, and was perceived as a
symbol of success. Hokusai frequently depicted irises
in his picture books, and he discussed how they
should be coloured in his *Ehon saishiki-tsū* (Picture
book of colouring) of 1848. The colouring in this
impression is remarkably well preserved.

42

Mishima – morning mist
Mishima – asagiri
Colour print from woodblocks. *Ōban*, 257 × 353.
Signed: *Hiroshige ga*. Publisher: *Hōeidō* (Takenouchi
Magohachi). Censor's seal: *kiwame. c.*1833
Given by T. H. Riches 1913

Hiroshige was the son of a government (*bakufu*) fire
officer. He became a pupil of Utagawa Toyohiro (see
Plate 30), and also studied Kanō-, Nanga-, and
Shijō-style painting. He adopted the name
Hiroshige in 1812 and his early prints with that
signature are *bijin-ga* and landscapes in small format.
It was only in the 1830s that he began designing the
landscape prints in *ōban* format for which he is
famous. His final words, recorded in a poem, are an
apt reflection of his achievement as a landscape
artist:

> *I have laid down my brush in the east* [Edo]
> *and depart to enjoy*
> *the wondrous scenery of the west* [the Buddhist
> Paradise].

Station no.12 in the series *Tōkaidō gojūsan tsugi no
uchi* (Fifty-three stations of the eastern coast road),
the first and most successful of Hiroshige's many
Tōkaidō sets, and his first important *ōban* prints (his
first *ōban* landscape series was a set of ten Edo views
of *c.*1831). The ambitious publication was no doubt
a response to the success of Hokusai's 'Thirty-six
views of Mount Fuji' (see Plates 34-5). The first few
prints to be completed in 1833 were published
jointly by Tsuruya Kiemon and Takenouchi
Magohachi, but the remainder were published
by Takenouchi alone. The complete set, bound
with frontispiece and title-page, was issued with
Takenouchi's mark (*Hōeidō*) in early 1834, and it
is therefore known as the *Hōeidō Tōkaidō*. It was
reissued in many later editions.

The Tōkaidō highway along the Pacific coast was
the most important road in Japan, connecting the
old capital Kyoto with the new capital Edo. The
journey of 300 miles took about two weeks and was
undertaken in stages. Travellers rested overnight at
one of fifty-three 'stations' designated by the first
Tokugawa *shōgun* in 1601. Toll-barriers along the
route helped the government to control travel and
thereby restrict opportunity for revolt. Nevertheless,
thousands travelled the road each year: pilgrims,
entertainers, messengers, traders, and large retinues
of *samurai* serving the *daimyō* who needed to travel
along the Tōkaidō to comply with the *sankin kōtai*
requirement that they reside in Edo every other
year. Travellers were serviced by a multitude of
innkeepers, tea-house owners, palanquin-bearers
and porters. During the day they paused at inns and
tea-houses to sample the various local delicacies.
Some of the stations also offered the chance to
change porters and horses.

By the 1830s there was a growing interest in
travel for its own sake, and a corresponding market
for guidebooks and albums of views of famous
places on the route. A popular comic novel by

Jippensha Ikku described the adventures along the
Tōkaidō of two rascals from Edo – *Tōkaidōchū
hizakurige* (By Shanks's pony along the Tōkaidō),
1802-22 – giving a taste of the sense of freedom
experienced by travellers as they escaped the
constraints of town life in a feudal society:

> On the road, also, one has no trouble from bill-
> collectors at the end of the month, nor is there
> any rice-box on the shoulder for rats to get at.
> The Edo man can make acquaintance with the
> Satsuma sweet-potato, and the flower-like Kyoto
> woman can scratch her head with the skewer
> from her dumpling. If you are running away for
> the sake of the fire of love in your heart, you can
> go as if you were taking part in a picnic, enjoying
> all the delights of the road. You can sit down in
> the shadow of the trees and open your little tub
> of *sake*, and you can watch the pilgrims going by
> ringing their bells. Truly travelling means
> cleaning the life of care. With your straw sandals
> and your leggings you can wander wherever you
> like and enjoy the indescribable pleasures of sea
> and sky.

Hiroshige made the journey along the Tōkaidō
around the eighth month of 1832, when he was
appointed by the government in Edo to accompany
the annual procession taking a gift of horses to the
emperor in Kyoto, in celebration of the rice harvest.
Although the journey was made in early autumn,
Hiroshige used his imagination to vary the seasons
and weather when he came to design the prints.
Some of his compositions were inspired by views
already made familiar by the picture book *Tōkaidō
meisho zue* (Famous views on the Tōkaidō),
published in 1798 with illustrations by Shunsen,
Masayoshi and others.

Mishima was famous for its Shintō shrine and
offered a welcome place of rest after the steep
mountains of Hakone. In this print a group of
travellers pass by the *torii* gate of the shrine. One is
on a horse led by a man wearing a straw raincoat;
another is carried in a palanquin (*norimono*).
Palanquins differed considerably in size and comfort
and some could only be used by persons of *samurai*
rank or with special government permission. They
were graded according to the length and shape of
the poles, the number of bearers, whether they were
open or enclosed by curtains, and whether or not a
cushion was provided.

43
Numazu – twilight
Numazu – tasogare no zu
Colour print from woodblocks. *Ōban*, 225 × 352.
Signed: *Hiroshige ga*. Publisher: *Hōeidō* (Takenouchi
Magohachi). Censor's seal: *kiwame. c.*1833.
Given by T. H. Riches 1913

Station no.13 from the series *Tōkaidō gojūsan tsugi no
uchi* (Fifty-three stations of the eastern coast road) of
1833-4. Numazu is around three-and-a-half miles
from Mishima at the point where the Kanō River
flows into the sea, although the river in this print is
the Kise, which joins the Kanō just above Numazu.
Travellers at dusk are nearing the end of their day's
journey – travellers were not allowed to pass
through the barriers at the stations at night. The
pilgrim carrying the long-nosed mask of Saruta-
hiko (god of the road) on his back is probably on his
way to the Shintō shrine of Kompira on the island
of Shikoku, where such a mask was used in
ceremony.

44
Mariko – Meibutsu tea-house
Mariko – Meibutsu chaya
Colour print from woodblocks. *Ōban*, 222 × 355.
Signed: *Hiroshige ga*. Publisher: *Takemago Tsuruki*
(Takenouchi Magohachi and Tsuruya Kiemon).
Censor's seal: *kiwame. c.*1833.
Given by T. H. Riches 1913

Station no.21 from the series *Tōkaidō gojūsan tsugi no
uchi* (Fifty-three stations of the eastern coast road) of
1833-4. This is a faithful portrayal of the scenery at
Mariko, which was famous for its early plum
blossoms, *tororo-jiru* (yam-paste soup), and for the
famous poem by Bashō celebrating these delights:

> *Young leaves of plum,*
> *and at the Mariko station*
> *a broth of grated yams.*

The guidebooks to the Tōkaidō listed the culinary
speciality of each station so that travellers could
sample the local delicacy. In this print we see one
of the fifteen or so tea-houses at Mariko that
specialised in selling *tororo-jiru* to travellers. The soup
is advertised on the large sign leaning against the
shop. The serving woman carrying a baby on her
back recalls the description of the landlord's wife in
the comic novel *Tōkaidōchu hizakurige* (By Shanks's
pony along the Tōkaidō):

> . . . they got to Mariko. Here they entered a tea-
> house. 'Shall we have a meal?' suggested Kita.
> 'This place is famous for its yam soup.'
> 'Landlord', called Yaji. 'Have you got any yam
> soup ready?'
> 'Yes sir', replied the landlord. 'It'll be ready in a
> minute.' . . . A tousle-haired woman, with a baby
> on her back, came in at the back door dragging
> her straw sandals along the ground and
> grumbling . . .

45
Shōno – white rain
Shōno – haku-u
Colour print from woodblocks. *Ōban*, 224 × 348.
Signed: *Hiroshige ga*. Publisher: *Hōeidō* (Takenouchi
Magohachi). Censor's seal: *kiwame. c.*1833
Given by T. H. Riches 1913

Station no.46 from the series *Tōkaidō gojūsan tsugi no
uchi* (Fifty-three stations of the eastern coast road) of
1833-4. Shōno is situated on the left bank of the
Suzuka River in Ise Province (now Mie Prefecture),
but the scenery in the print is largely imaginary and
Hiroshige makes no reference to the legend usually
associated with Shōno (Yamato Takeru no Mikoto
being turned into a swan). Instead he concentrates
on the weather, with distant bamboo-groves bend-
ing under the slanting onslaught of the rain. In
the foreground, palanquin-bearers struggle uphill,
their passenger using his raincoat as a makeshift
canopy. Villagers run for shelter, two wearing straw
rain-capes (*mino*). Another man is hidden by his
paper umbrella (*bangasa*) which threatens to collapse
as he points it into the storm. This umbrella bears
the name of the publisher (*Takenouchi*) and part of
the series-title, parodying the appearance on such
cheap, often rented, umbrellas of the trademarks
(*yago*) of shops and inns. The term 'white rain' (*haku-
u*) used in the title of the print indicates a sudden
daytime shower. It is one of the numerous evocative
descriptions distinguishing different types of rain in
Japanese.

42

43

44

45

46

View of the Ommaya embankment in Edo
Tōto Ommayagashi no zu
Colour print from woodblocks. *Ōban*, 249 × 370.
Signed: *Ichiyūsai Kuniyoshi ga*, with *toshidama* seal.
Publisher: Yamaguchiya Tōbei. *c.*1834.
Given by T. H. Riches 1913

Kuniyoshi was a pupil of Utagawa Toyokuni. He also studied Tosa-, Kanō- and Maruyama-style painting. His early prints were book illustrations and actor subjects in a similar style to Utagawa Kunisada (see Plate 52), although unlike his fellow pupil, Kuniyoshi did not meet with early success. It was not until the late 1820s that he established himself with a series of prints of warrior-heroes (*musha-e*). He also designed *bijin-ga*, and in the 1840s, when actor prints were banned, he embarked on the spectacular warrior-triptychs that dominated his output for the rest of his life. In the 1830s and early 1840s he designed a number of remarkable landscapes, which are especially notable for their adoption of European modes of depiction, such as shading. Kuniyoshi is said to have collected Western prints.

From an untitled set of views of Edo published by Yamaguchiya Tōbei, this print shows a rainstorm on the banks of the Sumida River at Miyoshi-chō in Asakusa, Edo. It is typical of Kuniyoshi's adoption of pictorial conventions from European copperplate prints, such as recession emphasised by diminishing forms in the distance, patches of shading and texture on the ground, lines of hatching in the clothes, and the grey-shaded clouds. The paper umbrella (*bangasa*) on the left shelters three labourers and bears the name of the Yamatoya shop or restaurant at Yanagishima. The man on the right carries a stock of extra umbrellas under his arm. He may be an umbrella vendor, who also hires umbrellas, taking advantage of the storm. His umbrella is inscribed with the rental number *1861*, and also with Yamaguchiya's publishing mark (compare the similar conceit in Plate 45). Further umbrellas can be seen clustered in the Ommayagashi ferry boats taking passengers across the river. The man in the centre-foreground with no apparent interest in umbrellas is a fisherman, with his catch in a bucket slung over his fishing-pole.

47
Returning sails at Yabase
Yabase kihan
Colour print from woodblocks. *Ōban*, 227 × 353.
Signed: *Hiroshige ga*. Publisher: *Hōeidō* (Takenouchi
Magohachi). Censor's seal: *kiwame*. *c*.1834.
Given by the Friends of the Fitzwilliam (P.314-1941)

From the series *Ōmi hakkei no uchi* (Eight views of
Ōmi) published by Takenouchi Magohachi and
Yamamoto Heikichi. The set was advertised by
Takenouchi in the advertisement (*okuzuke*)
accompanying the album version of the *Tōkaidō*
(see Plate 42) in 1834.

The eight views of Lake Biwa in Ōmi Province
(*Ōmi hakkei*) were established by 1500 as Japanese
equivalents of the traditional Chinese series 'Eight
views on the Xiao and Xiang Rivers', near Lake
Dongting in Hunan Province (see p.15 above). The
setting of the water and mountains around Lake
Biwa near Kyoto was chosen partly because it
provided points of similarity with the Chinese
models, but also because Lake Biwa was one of the
most important icons of the Japanese landscape.
According to legend, it was formed at the same time
as Mount Fuji in the year 286 BC when the earth
opened up to create a large lake, some sixty miles
long by twenty wide, in the shape of a *biwa* (four-
stringed lute; seen on the robe of the courtesan in
Plate 60). The other seven titles in the Ōmi set are
Awazu seiran (Sunset glory at Awazu), *Hira bosetsu*
(Lingering snow on Mount Hira), *Ishiyama shūgetsu*
(Autumn moon at Ishiyama), *Karasaki no yau* (Night
rain at Karasaki), *Katata rakugan* (Wild geese
descending at Katata), *Mii banshō* (Evening bell at
Mii Temple), *Seta sekishō* (Evening glow at Seta).

By the time Hiroshige designed this series, sets of
hakkei (eight views) of other districts, such as Edo,
usually replaced the views of Lake Biwa (see Plate
49), and this was the first time that the classic
locations appeared in the newly popular *ōban*
landscape format. Hiroshige chose to use a lyrical
style with elements of Nanga (literati artist's style),
imbuing the views with a sense of classical poetry
suited to the origins of the set. The publisher's
advertisement indicated that the set was intended as
'a series of pictures done in muted colours in the
style of the old monochromes'. This accounts for the
monochrome treatment of the near shore, which has
the delicate character of *sumi* drawings, although the
other colours are less muted than in other prints
from the series.

Each view in the series has its canonical poem
printed in the square cartouche beside the red title-
cartouche. In this case the poem reads:

> *The boats that come with*
> *swelling sails to Yabase*
> *have been chased by the wind*
> *along the coasts of Uchide.*

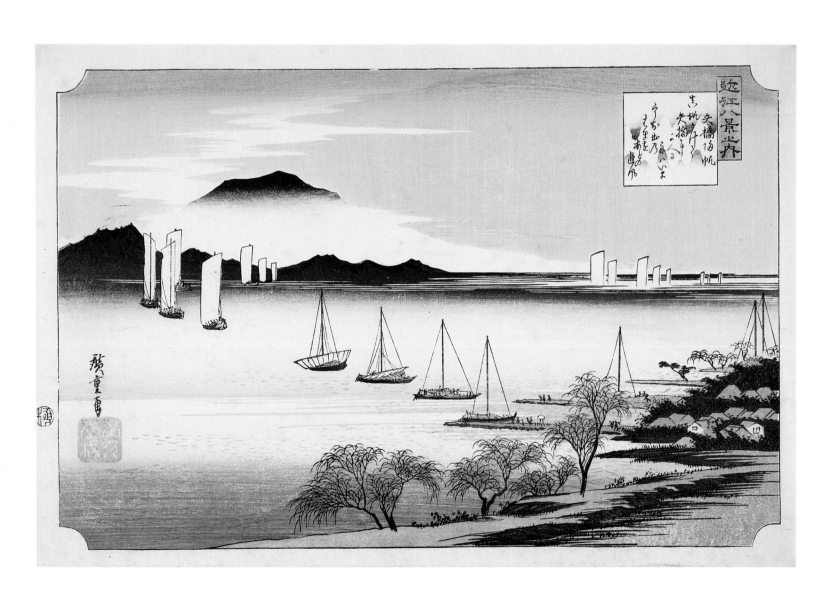

48

Mountain and river on the Kiso road

Kisoji no sansen

Colour print from woodblocks. *Ōban* triptych, each sheet 366×240/248.

Signed: *Hiroshige hitsu*. Artist's seal: *Bokurin shōja*.

Publisher: *tsuta* (Okazawaya Taheiji). Date seal: *Snake 8* (8/1857). Censor's seal: *aratame*. 1857

Given by the Friends of the Fitzwilliam with a contribution from the National Art Collections Fund (P.1-1993)

The 'snow' triptych from the untitled set of three landscape triptychs on the traditional theme of *setsugetsuka* (snow, moon and flowers), published by Okazawaya Taheiji in 1857. Each was signed with a different seal by the artist, and the calligraphic style for each title was intentionally varied: *gyōsho* style (snow), *reisho* style (moon), and *sōsho* style (flowers).

The three elements of *setsugetsuka* were considered 'the three friends of the poet', first mentioned by Hakurakuten (Be Zhui: 772-846), the Chinese poet reputedly sent by the Tang emperor to Japan. The theme occurs in *Makura no sōshi* (The pillow book) by Sei Shōnagon (*c*.966-1017) and in later collections of verse. The three words were sometimes used in place of numerals to number sequences such as the volumes of a book, or the prints in a set. They were associated with the seasons: the moon with early autumn, snow with winter, flowers with spring (together with birds, they made up the four seasonal elements: *kachō gessetsu*).

This print shows the mountain road between Kyoto and Edo, which had been the subject of one of Hiroshige's series of prints (*Kisokaidō*, *c*.1836-43). The abstract quality of the design recalls Chinese painting styles. As in Hiroshige's late landscape paintings, the human figure is virtually absent: not since Hokusai's views of Fuji (Plates 34-5) had there been a vision of nature in *ukiyo-e* prints so uncompromising in its evocative power.

Utagawa HIROSHIGE 1797-1858

49
**Panorama of eight views of Kanazawa
under full moon**
Buyō Kanazawa hasshō yakei
Colour print from woodblocks. *Ōban* triptych,
each sheet 369 × 248/250.
Signed: *Hiroshige hitsu.* Artist's seal: *Ichiryūsai.*
Publisher: *tsuta* (Okazawaya Taheiji). Date seal: *Snake
7* (7/1857). Censor's seal: *aratame.* 1857.
Oscar Raphael Bequest 1941 (P.189-1946)

The 'moon' triptych from the set of three landscape
triptychs made at the end of Hiroshige's life on the
traditional theme of *setsugetsuka* (snow, moon and
flowers). The eight famous views of Kanazawa, in
Musashi Province (now Kanagawa Prefecture), were
the subject of several sets of prints by Hiroshige.
Although he would have had the opportunity to
visit the area around Kanazawa, he may have derived
some of the features in this view from an illustration
in the popular gazetteer *Edo meisho zue* (Illustrations
of famous places of Edo) by Saitō Gesshin (1804-
78), which was published in twenty volumes in
1834-6 with careful and accurate illustrations by
Hasegawa Settan (1778-1843). Gesshin was a writer
and *ukiyo-e* print censor who was closely associated
with Hiroshige. The wetlands shown in this print
have now been destroyed by filling-in of the coast.

The landscape is seen under the light of the
moon, which was associated with the beginning of
autumn (the seventh month) when moon-viewing
(*tsukimi*) was especially popular. The formation of
wild geese, seen flying across the moon, was another
poetic element evoking autumn.

武陽金澤八勝夜景

Utagawa HIROSHIGE 1797-1858

50

The rapids of Naruto in Awa Province
Awa Naruto no fūkei
Colour print from woodblocks. Ōban triptych,
each sheet 376×248/254.
Signed: *Hiroshige hitsu*. Artist's seal: *Tōto ikka*.
Publisher: *tsuta* (Okazawaya Taheiji). Date seal: *Snake
4* (4/1857). Censor's seal: *aratame*. 1857.
Given by the Friends of the Fitzwilliam 1941
(P.317-1941)

The 'flowers' triptych from the set of three
landscape triptychs made at the end of Hiroshige's
life on the traditional theme of *setsugetsuka* (snow,
moon and flowers). In most 'snow, moon and
flowers' sets, the 'flowers' print was a view of cherry
blossom. Here, in a poetic conceit, the flowers are
represented by the whirlpools of the famous rapids
at Naruto, between the islands of Awaji and
Shikoku, which is seen in the distance. *Nami no hana*
(wave-blossoms) was a popular idiom in poetry,
denoting the blossom-like caps of waves. An
example is Bashō's *hokku*:

> *Wave-blossoms –*
> *as snow to water*
> *and blooming out of season.*

There is a colourful story telling how the penniless
Hiroshige made the journey to Naruto, selling fans
along the road to pay his way, and hired a boat to
float around in the rapids in preparation for
designing this composition, but this may well be
apocryphal. More likely the view was based on
illustrations by Tankoshitsu Bokkai in the book *Awa
meisho zue* of 1811.

51

Sawamura Tanosuke as Ashikage Yorikane attempting to murder Takao, played by Onoe Matsusuke

Colour print from woodblocks. *Ōban* vertical diptych (*kakemono-e*), 763 × 260.
Signed: *Toyokuni ga.* Publisher: Suzuki Ihei.
Publisher's approval seal: *Yamashiroya Tōemon.*
Censor's seal: *kiwame.* 1813.
H. S. Reitlinger Bequest 1991 (P.619-1991)

For an earlier print by Toyokuni see Plate 29. Toyokuni was the teacher of the Utagawa-school artists Kunisada and Kuniyoshi, whose work is reproduced on the following pages. He was closely involved with the *kabuki* theatre and was a close associate of some of the leading actors of his time.

The story of the retired *daimyō* Ashikaga Yorikane and his mistress, the courtesan Takao, derived from a historical incident that occurred in 1741. In *kabuki* theatre, the story was often combined with plots concerning the feuds of the Date family of Sendai. This print was published in association with the performance of the play *Sono omokage Date no utsushi-e* (The magic-lantern-shadow image of Date) at the Nakamura Theatre in Edo during the third month of 1813, which featured the actors named on the print in these roles. The print shows the 'hanging from the crown-of-the-head' scene, which is typical of the grotesque or macabre effects that became popular after the Kansei reforms of 1789-95. Yorikane suspects that Takao is continuing an affair with a former lover. In a rage of jealousy he suspends her over the side of a boat and drops her into the waves by slicing through her hair with his sword. The scene was a sensational hit with the audience. It may have been performed on this occasion for the first time on the *kabuki* stage, adapted from a similar scene in *bunraku*. However, Toyokuni's depiction is remarkably similar to an illustration in the book *Ehon kinkadan* (Illustrated story of the golden flower) by Hayami Shungyōsai (*c.*1760-1823), published in 1808.

The actor Sawamura Tanosuke (1788-1817) usually played women's roles, but in this performance he honoured his predecessors by playing a male lead especially associated with the Sawamura school of actors (see Plate 7 for an earlier generation Sawamura actor). His performance was acclaimed. On the other hand, the actor playing Takao, Onoe Matsusuke (1784-1849), was better known in the role of a dandy, and this foray into female impersonation was not well received.

The *kakemono-e* format became popular again in the early 1800s, when the fashion for *hashira-e* (see Plates 10-11, 17-18) had somewhat declined. In this example two *ōban* sheets are joined together to form a single, tall composition.

Kunisada was born into an affluent commoner family in Edo and became a pupil of Utagawa Toyokuni around 1800. He was the most prolific and successful designer of his generation. He worked as a book illustrator before moving into theatrical prints, rivalling Toyokuni in that field by 1810. Around 1814 he started designing *bijin-ga*, although theatrical prints remained predominant in his output. From 1844 he signed himself with the name of his master *Toyokuni*, and he is often referred to as Toyokuni III; another pupil, Utagawa Toyoshige (1777-1835), inherited the name immediately after Toyokuni's death and is therefore known as Toyokuni II.

52

The wrestling match between Matano Gorō Kagehisa and Kawazu no Saburō Sukeyasu

Colour print from woodblocks. *Ōban* triptych, each sheet 378 × 259.

Signed: *Ichiyūsai Kunisada ga*. Publisher: *Kawaguchiya Uhei*. Censor's seal: *kiwame*. *c*.1811-13.

Given by Sir W. P. Elderton 1955 (P.214-1955)

One of two early triptychs by Kunisada showing the final sumo bout in a legendary sequence enacted in 1176 before the general Minamoto no Yoritomo after a hunting expedition on Mount Akazawa. These were Kunisada's first sumo prints, a field hitherto dominated by Katsukawa-school artists, and he relied heavily on prints by Shun'ei for the poses of the wrestlers. Both prints depict the moment when the reluctant Kawazu defeated the hitherto unbeaten Matano by throwing him to the ground after employing a new hold (it is still used and is known as the *Kawazu*). The umpire Ebina Gempachi is shown signalling the victory with his fan (*uchiwa*). Kawazu was murdered the next day and the tale of how his two sons, Soga Jūrō and Gorō, avenged his death became popular in *kabuki* and *ukiyo-e* (see Plates 5 and 55). The wrestling match was sometimes enacted as a preface to the plays.

俣野五郎景久

一雄齋國貞画

海老名源八

一雄齋國貞画

53
***Ōtsu-e* coming alive**
Toki ni ōtsu-e kitai no mare-mono
Colour print from woodblocks. *Ōban* triptych,
each sheet 364 × 252.
Signed: *Ichiyūsai Kuniyoshi ga*, with red *kiri* seal.
Block-cutter: *hori Takichi*. Publisher: *Minatoya Kohei*.
Censors' seals: *kinugasa, hama* and *mera, murata*.
c.1847–52.
Given by T. H. Riches 1913

Kuniyoshi is depicted among characters coming
alive from the type of folk paintings called *ōtsu-e*
(Ōtsu pictures), after the city on the Tōkaidō
highway at Lake Biwa, where they were produced
and sold as souvenirs to pilgrims and travellers. The
rustic *ōtsu-e* style, with its rapid, broad brushstrokes,
was occasionally used by major *ukiyo-e* artists.
Kuniyoshi evidently intended a comparison
between himself and the legendary painter Ukiyo
Matabei, loosely based on Iwasa Matabei (1578–
1650), who was supposed to be the founder of the
ukiyo-e school and the inventor of *ōtsu-e*. Various
legends tell of the characters in Matabei's paintings
coming alive and these were sometimes depicted
in paintings and prints, including a diptych by
Kuniyoshi published in 1853.

Although the artist's face is hidden by a
fluttering picture, the fan (*uchiwa*) lying beside him
is decorated with Kuniyoshi's personal *kiri*
(paulownia) seal, which also appears as a red crest
beneath his signature. The cat confirms the
identification; Kuniyoshi could not work without
one of his favourite cats beside him. This hidden
identity is a clue to the fact that there are other
portraits to be discovered in the print: the faces of
the characters coming alive are actually unnamed
portraits of famous actors. This was an ingenious
way of getting round the prohibition against
publishing actor prints contained in an edict of
1842. Among favourite *ōtsu-e* subjects depicted is the
legendary warrior-priest Benkei (see Plate 54)
carrying off the bell of Mii Temple (foreground of
left sheet).

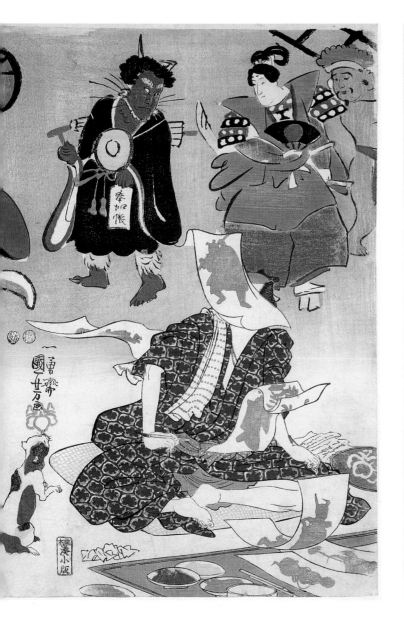
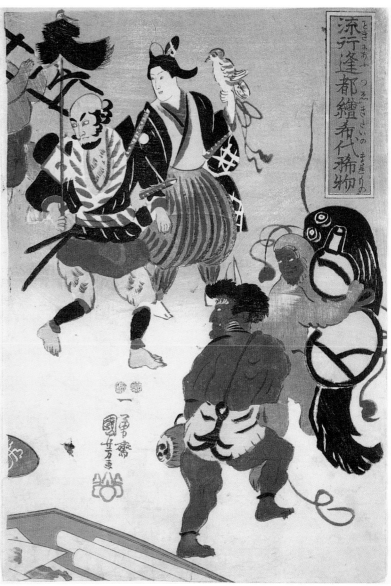

54
Yoshitsune's ship attacked by the Taira ghosts
Colour print from woodblocks. Ōban, 365 × 252.
Signed: *Chōōrō Kuniyoshi ga*, with red *kiri* seal.
Publisher: *Jōshūya Jūzō*. Date seal: *Ox 1* (1/1853).
Censors' seals: *hama, magome* 1853.
Given by T. H. Riches 1913

From the series of sixteen prints *Hodo Yoshitsune koi no Minamoto ichidaikagami* (A biography of Yoshitsune, darling of the Minamoto), published by Ibaya Kyūbei and Jōshūya Jūzō in the early 1850s. The title of the series is in a red cartouche framed in bamboo and decorated with the dwarf bamboo leaves and bellflowers of the Minamoto family crest (*mon*), which appears on Yoshitsune's tunic. The decorated scroll (top left) contains a brief description of the episode depicted.

The story of the feud between the Minamoto (Genji) and Taira (Heike) clans was told in the *Heike monogatari* (Tale of the Heike) and the *Gikeiki* (Story of Yoshitsune), and retold many times in plays and prints, most of them featuring the heroic deeds of Minamoto no Yoshitsune and his loyal henchman the warrior-priest Benkei (see also Plates 37 and 53). The decisive sea-battle took place in 1185 at Dan-no-ura in the straits between Kyūshū and the mainland. The Taira fleet was destroyed by Yoshitsune's forces and the leading members of the Taira family were slain or drowned, including the child-emperor Antoku, who disappeared beneath the waves in the arms of his grandmother together with the imperial regalia.

The legendary episode illustrated in this print occurred soon afterwards when Yoshitsune, hounded by the forces of his jealous half-brother Yoritomo, set sail for the island of Shikoku. Off the coast of Settsu a terrible storm blew up, spirit-fires appeared in the waves and the ghosts of Taira Tomomori and the Taira warriors slain or drowned at Dan-no-ura rose from the depths of the sea and threatened to sink the ship. Several versions of the story, most notably the *nō* play *Funa Benkei*, tell how Benkei quelled the spirits by reciting prayers until they sank back into the waves and the storm subsided. Kuniyoshi depicted this episode several times, mainly in triptychs, with Benkei usually shown grasping his rosary beads, which are not visible in this print.

As well as the multitude of ghosts, monstrous crabs with faces on their backs are about to board the ship. These are part of the legend that came to haunt the site of the battle. Lafcadio Hearn (1850-1904) described 'strange crabs found there, called Heike, which have human faces on their backs, and are said to be the spirits of the Heike warriors. But there are many strange things to be seen and heard along that coast. On dark nights thousands of ghostly fires hover about the beach, or flit above the waves – pale lights which the fishermen call *oni-bi*, or demon-fires; and whenever the winds are up, a sound of great shouting comes from the sea, like a clamour of battle.' (*Kwaidan*, 1904).

55

**The actor Bandō Hikosaburō V in the role of
Kudō Saemon**

Colour print from woodblocks with blind
embossing (*karazuri*), fabric-printing (*nunome-zuri*)
and burnishing (*tsuya-zuri*). Ōban, 340 × 240
(irregular).
Signed: *Kiō Toyokuni hitsu* (from the brush of old
man Toyokuni in his seventy-seventh year) and in
the landscape: *Hiroshige*, with *Hiro* seal. Block-cutter:
hori Take (Yokokawa Takejirō). Publisher: *Uoei* (Uoya
Eikichi). Censor's date seal: *aratame cock 12*
(12/1861). 1861.
Given by David Scrase 1994 (P.113-1994)

From the series *Soga hakkei jihitsu kagami* (Eight
views of the Soga with models of [the actor's own]
calligraphy) published by Uoya Eikichi. Each print
shows an actor as a character from one of the many
kabuki plays based on the revenge tale of the Soga
brothers, which were traditionally performed at
New Year. This print was published at the end of
1861, no doubt as advance publicity for the
appearance of Bandō Hikosaburō in this role in the
play *Sano kei zu Soga no gosho-zome* (A Sano lineage
Soga of courtly hue) performed at the Nakamura
Theatre in the first month of 1862. The inset
landscape shows Susono, the moor at the foot of
Mount Fuji where the villain Kudō Saemon
Suketsune was murdered by the Soga brothers.

The crest (*mon*) depicted on the actor's robe, and
also on the white curtain in the background, is the
Kudō crest of the character. A New Year *hokku* poem
signed with the *hokku* name of the actor, *Shinsui*,
and printed in imitation of his own calligraphy,
appears down the right:

> *A blessing to the branches*
> *which still do not sprout*
> *the east wind of spring.*

Kunisada designed many series of prints with
landscapes provided by Hiroshige, and after
Hiroshige's death he collaborated with Hiroshige's
pupil Ichiyūsai Shigenobu, who then adopted the
name Hiroshige II. The format was first used in
1852 in a set of actors by Kunisada with background
scenes of the Tōkaidō by Hiroshige. This was such a
success that 7000 impressions of some designs in the
series were sold.

This print is a fine example of the special
printing effects lavished on early editions of prints
at this period, with burnishing (*tsuya-zuri*) on the
actor's hair, crisply embossed patterns (*karazuri*) on
his collar and hairband and on the white curtain in
the landscape, embossed lines modelling the upper
slopes of Fuji, and subtle fabric-printing (*nunome-
zuri*) on the poem-slip. The complexity of
Kunisada's designs after he adopted the name
Toyokuni was much admired by his contemporaries
who recognised its daring 'modern style' (*imayō*).

56

Summer – the river at Ryōgoku

Ka – Ryōgoku kawa

Colour print from woodblocks. *Uchiwa*, 223 × 296.
Signed: *Toyokuni ga* in *toshidama* cartouche. Block-
cutter: *hori Take* (Yokokawa Takejirō). Publisher:
Jōshūya Kinzō. Censor's date seal: *horse kiwame*. 1858.
Part of the Messel-Rosse fan collection given by the
Friends of the Fitzwilliam with the assistance of the
National Heritage Memorial Fund 1985 (P.6-1985)

57

Winter – Shinobazu Pond

Tō – Shinobazu ike

Colour print from woodblocks. *Uchiwa*, 225 × 297.
Signed: *Toyokuni ga* in *toshidama* cartouche. Block-
cutter: *hori Take* (Yokokawa Takejirō). Censor's date
seal: *horse kiwame*. 1858.
Part of the Messel-Rosse fan collection given by the
Friends of the Fitzwilliam with the aid of the
National Heritage Memorial Fund 1985 (P.8-1985)

Plates 56 and 57 show prints from an untitled set of
four prints depicting the four seasons, which were
intended to be mounted as the type of non-folding
fans called *uchiwa* (*uchiwa* can be seen depicted in
Plates 28 and 52-3). Traces of yellow-coloured paper
used to mount these examples in the past remain
around the edge of the sheets. The tradition of
designing prints to decorate fans probably began in
the second quarter of the eighteenth century. The
blocks were rounded at the edges and cut away at
the bottom where the bamboo ribs of the support
joined the handle. Faint indentations from the ribs
can be seen on these prints. As fans tended to be
used, worn out and then discarded, relatively few fan
prints have survived. Those that remain are normally
examples that were never mounted, such as those
bound in a fan-seller's sample book.

This series is notable for the way Kunisada has
portrayed complex pictorial space in the awkward
confines of the *uchiwa* format. Each print has a
subtitle giving the location in Edo and a poem
(*senryū*) commenting on the scene. In this print a
woman has just crossed Yanagi Bridge over the
Kanda River on her way back from the bathhouse.
She clasps her cotton summer robe (*yukata*) under
her arm, combs her hair and holds between her
teeth a 'bran bag' (*nuka-bukuro*), which was used in
the manner of soap to clean the skin. The sign on
the right with the common advertising slogan,
Funayado – senkyaku banrai (Boat-inn – thousands of
customers, ten thousands of visits), belongs to one of
the restaurants that provided boat-service, either for
picnics on the river or to take people from the busy
entertainment district of Ryōgoku up the Sumida
River to the Yoshiwara (see p.10 above). The water-
taxis (*chokibune*) used for this purpose can be seen
on the river in the background.

From the same set as Plate 56. A *geisha* is practising
a ballad from the book open in front of her, and
accompanying herself on the *shamisen*. She is
probably sitting in an upstairs room of the
Kawachirō restaurant. The view through the
window shows the shrine to Benten (goddess of
water) on the island constructed in Shinobazu Pond
in imitation of Chikibu Island in Lake Biwa.

58

Night view of Sanya Canal and Matsuchi Hill
Matsuchiyama Sanya-bori yakei
Colour print from woodblocks, with mica (*kira*).
Ōban, 339 × 228.
Signed: *Hiroshige ga*. Publisher: *Uoei* (Uoya Eikichi).
Date seal: *Snake 8* (8/1857). Censor's seal: *aratame*.
1857.
Given by T. H. Riches 1913

59

**Asakusa rice fields during the festival of
the cock**
Asakusa tambo torinomachi mōde
Colour print from woodblocks. Ōban, 337 × 225.
Signed: *Hiroshige ga*. Publisher: *Uoei* (Uoya Eikichi).
Date seal: *Snake 11* (11/1857). Censor's seal: *aratame*.
1857.
Given by T. H. Riches 1913

From the series *Meisho Edo hyakkei* (One hundred famous views of Edo), published by Uoya Eikichi in 1856-8 (around the same time as the triptychs in Plates 48-50). The artist had already investigated the famous and less famous views of Edo in his seven-volume illustrated book, *Ehon Edo miyage* (Souvenirs of Edo), published *c*.1850-5. In choosing the locations and in designing some of the views, Hiroshige relied on the illustrated gazetteer *Edo meisho zue* published in 1834-6 (see also Plate 49). The set ran to 119 prints, with several designed by Hiroshige II (see Plate 55), and a title-page designed by Baisotei Gengyo (1817-80), which lists the subjects according to season.

This print is in the section for spring. A *geisha* with a bright red apron (*kedashi*) follows a guide with a lantern along the bank of the Sumida River, probably on her way to (or from) a banquet at a local restaurant. The mouth of the Sanya Canal is visible on the far shore, spanned by Imado Bridge, with Matsuchi Hill rising above; this was the point where visitors travelling to the Yoshiwara by boat (see Plate 56 and p.10 above) would alight before walking along the Nihon embankment. Either side of the bridge shine the lights of restaurants: the Takeya on the left, and the recently opened Yūmeirō on the right. The near shore was known as Mukōjima, and was famous for its cherry blossoms in spring. On the right a cherry tree rises to frame the night sky, where the grain of the woodblock is punctuated by stars, beneath a band of darkness flecked with glittering mica. An alternative printing has a more elaborately coloured cartouche, and extra shading on the tree trunk.

From the winter section of the series *Meisho Edo hyakkei* (One hundred famous views of Edo).

Through an upstairs window of a Yoshiwara brothel the distant *Torinomachi* procession can be seen winding its way to the Washi Daimyōjin Shrine. The festival was held on the days of the cock in the eleventh month (the date of publication of this print). The distant figures can be seen carrying *kumade* – bamboo rakes decorated with symbols of prosperity for the year ahead. Smaller versions of these in the form of hairpins are lying on the floor, probably souvenirs purchased at the shrine and brought as a gift by the visitor who is behind the screen with a courtesan. This was the busiest day of the year in the Yoshiwara, a day when each courtesan had to take a customer or else pay the fee to the brothel owner out of her own pocket. Above the hairpins is a parcel of *onkotogami* ('tissue for the honourable act'), often represented in *shunga*. On the window ledge is a mouth-rinsing bowl and a towel. On the horizon Fuji rises against a sky washed blood-red in the fading light.

There was an alternative printing, with a more elaborately coloured cartouche, brown shading on the roofs, and grey shading and embossing (*kimedashi*) on the cat.

60

Comparison of courtesans
Kurabe yūkun
Colour print from woodblocks with fabric-printing
(*nunome-zuri*). Ōban, 327 × 223.
Signed: *Gekkō*, with artist's seal: *Gekkō*.
H. S. Reitlinger Bequest 1991 (P.690-1991)

61

The poem on the cherry tree –
Kojima Takanori
Sakura no shi – Kojima Takanori
Colour print from woodblocks with blind
embossing (*karazuri*), 'lacquer' (*urushi*), and mica
(*kira*). Ōban, 327 × 221.
Signed: *Gekkō*, with artist's seal: *Ogata Gekkō*.
H. S. Reitlinger Bequest 1991 (P.705-1991)

Painter, print-designer, newspaper-illustrator, and decorator of pottery and lacquer ware, Gekkō was one of the most important and versatile artists of the Meiji period. He worked in the manner of the Japanese-style painter Kikuchi Yōsai (1788-1878) before studying *ukiyo-e*. His prints include landscapes in a wash-like style based on Shijō-style painting, *bijin-ga*, warriors and triptychs depicting the Sino-Japanese war. He was a prizewinner at the International Expositions in Chicago (1893), Paris (1900) and London (1910).

From the series *Fujin fūzoku zukushi* (Manners and customs of women) published by Sasaki Hōkichi in 1891. The scroll painting is signed, and was probably designed, by a pupil of Gekkō called Kōrei (or Kōryō). It was quite common for pupils to be assigned a self-contained part of a print to design.

The present-day courtesan is frightened by the scroll-painting, because someone has lit an incense burner underneath it, and it appears that the spirit of the courtesan of the past is rising out of the smoke.

In the three or four decades since the prints in Plates 55-9 were published, the Tokugawa regime had given way to the Meiji period, and Japan had undergone fundamental transformation and rapid modernisation. Newspapers were introduced in the early 1870s, photography had arrived, and the climate of printmaking had changed. Nevertheless, Plates 60-1 show how well the *ukiyo-e* style survived, with an unbroken line of prints of beauties and legendary figures. The tone, however, seems nostalgic when set beside the Western-derived style of contemporary prints covering current news events.

Technically, Meiji prints are often breathtaking, and the colours, which utilised newly available artificial (aniline) dyes, can be startlingly effective.

From the series *Nippon no hana zue* (Pictures of flowers of Japan) published by Sasaki Hōkichi in 1895. Each print shows a figure from historical legend in conjunction with a flower. In this case the subject is from the fourteenth-century military chronicle *Taiheiki* (Record of the great peace).

Takanori, feudal governor of the Province of Bizen, was a great student of the Chinese classics. In the garden of an inn where he knew the emperor Go Daigo was held captive, he stripped a patch of bark off one of the cherry trees, and carved an inscription in old Chinese characters on the trunk: *Oh heaven, do not destroy Kōsen whilst Hanrei is still with him.* He knew that Go Daigo would understand that this referred to an episode in Chinese history, when the captive Kōsen (Gou Jian) was liberated by his minister Hanrei (Fan Li); he also knew that the emperor's armed guard would not realise that the message informed their prisoner that help was at hand.

61

GLOSSARY

aiban print format measuring 340 × 220 mm

aratame censor's approval seal appearing on prints from 1848

bakufu military government of the *shōgun* in Edo

baren circular bamboo pad used to apply pressure during printing

beni rose-red organic pigment made from safflowers

beni-e hand-coloured prints using *beni*

benizuri-e 'printed *beni*' – prints from two or three colour-blocks

bijin-ga prints of beautiful women

bokashi technique of grading pigment on a block by hand-wiping

bunraku later name for *jōruri* puppet theatre

chōnin townspeople

chūban print format measuring 290 × 220 mm

daimyō feudal lords

Edo name of the capital city, later renamed Tokyo

Edo period 1603-1868; period of Tokugawa rule

egoyomi pictorial calendar prints

ga picture; drawn by

gakō preliminary, rough sketch for an *ukiyo-e* design

geisha 'accomplished person' – skilled hired entertainers (not prostitutes)

haikai playful linked verse (*renga*)

hanshita-e 'block copy picture' – final outline drawing for woodblock print

hashira-e pillar print

Heian period 794-1186; Heian was the early name for Kyoto

hitsu 'brush of'

hokku seventeen-syllable verse in *haikai* (later called *haiku*)

hōsho highest quality thick *kōzo* paper

hosoban print format measuring 330 × 150 mm

kabuki popular drama

kakemono-e hanging-scroll print

Kamakura period 1186-1336; period when the court was situated in Kamakura

kamuro child-attendants of *oiran*

Kanō traditional school of Chinese-style ink painting

karazuri 'empty printing' – blind embossing achieved by 'printing' uninked block

kentō registration mark used to align the blocks

kibyōshi 'yellow covers' – comic illustrated novelettes

kimedashi technique of embossing lines around forms using uninked blocks

kira mica – silvery iridescent pigment

kiwame censor's approval seal appearing on prints

komusō mendicant monks belonging to a branch of Zen Buddhism

kyōka 'crazy verse' of 31 syllables usually parodying classical forms

Maruyama realist style of painting named after Maruyama Ōkyo (1733-95)

Meiji period 1868-1912

michiyuki 'poetic journey' scene in *kabuki*

mitate 'likened' – parody

mon family crest; small denomination of currency

Muromachi period 1392-1573

Nanga 'southern painting' – literati painting based on Chinese models

nikawa animal collagen glue usually made from deer horns and hide

nishiki-e 'brocade-picture' – multicolour prints from five or more colour-blocks

nō classical masked drama; official *samurai* entertainment in Edo period

ōban print format measuring 390 × 265 mm

oiran high-ranking courtesan

ōkubi-e 'large-head' picture - bust or half-length portrait

onnagata male actor specialising in female roles

renga linked verse

rōnin masterless *samurai*

ryō large gold coin, the largest monetary unit

sake rice wine

samurai 'one who serves' – elite class of military retainers to *daimyō*

sankin kōtai policy of 'alternate attendance' in Edo for *daimyō*

senryū comic *hokku*

shamisen long-necked instrument with three strings

Shijō style/school of painting combining elements of *Maruyama* and *Nanga*

Shintō 'way of the gods' – native pantheistic religion of Japan

shinzō apprentice courtesan

shōgun military dictators of Japan from 1185 to 1868

shunga 'spring pictures' – erotica

sumi black ink made from soot and bound in *nikawa*

sumizuri-e 'printed *sumi* picture' – early monochrome prints

surimono 'printed thing' – privately-commissioned prints for special occasions

Tokugawa family of hereditary *shōgun* of Edo period

torii symbolic gateway to Shintō shrine

Tosa traditional school of Japanese-style painting

uchiwa round, non-folding fan

uki-e 'floating view' – prints imitating European system of perspective

ukiyo floating world

ukiyo-e picture(s) of the floating world

ukiyo-zōshi stories of the floating world

urushi-e 'lacquer picture' – named after the glossy effect of adding *nikawa* to the pigment

Yoshiwara licensed brothel quarter (*yūkaku*) in Edo

Zen sect of Buddhism in Japan emphasising meditation

BIBLIOGRAPHY

HISTORY

J. W. Hall (ed.), *The Cambridge history of Japan*, vol. 4, *Early modern Japan*, Cambridge, 1991

M. B. Jansen (ed.), *The Cambridge history of Japan*, vol. 5, *The nineteenth century*, Cambridge, 1989

C. Totman, *Early modern Japan*, Berkeley, 1993

LITERATURE, LEGEND AND KABUKI

Chiushingura; or The loyal league (translated by F. V. Dickins), London, 1880

Kabuki nempyō (compiled by Ihara Toshirō), 8 vols, Tokyo, 1956–60

The pillow book of Sei Shōnagon (translated by Ivan Morris), Harmondsworth, 1971

The tale of the Heike (translated by H. C. McCullough), Stanford 1988

Yoshitsune (Gikeiki) (translated by H. C. McCullough), Stanford, 1966

W. H. Edmunds, *Pointers and clues to the subjects of Chinese and Japanese art*, London, [1935]

A. S. and G. M. Halford, *The kabuki handbook*, Rutland and Tokyo, 1956

Lafcadio Hearn, *Kwaidan*, London, 1927

J. Ikku, *Tōkaidōchū hizakurige* (translated by T. Satchell), Kobe, 1929

H. L. Joly, *Legend in Japanese art*, London, [1914]

E. Miner, *An introduction to Japanese court poetry*, Stanford, 1968

E. Miner, H. Odagiri and R. E. Morrell, *The Princeton companion to classical Japanese literature*, Princeton, 1985

M. Shikibu, *The tale of Genji* (translated by E. G. Seidensticker), Harmondsworth, 1976

M. Ueda, *Bashō and his interpreters*, Stanford, 1992

B. Watson, *Saigyō: poems of a mountain home*, New York, 1991

PRINTS AND PAINTINGS

S. Asano and T. Clark, *The passionate art of Kitagawa Utamaro*, London, 1995

G. Avitabile, *Early masters: ukiyo-e prints and paintings from 1680 to 1750*, New York, 1991

F. Baekeland, *Imperial Japan: the art of the Meiji era (1868-1912)*, Ithaca, 1980

Beauty & violence: Japanese prints by Yoshitoshi 1839-1892, exh. cat., Society for Japanese Arts, Amsterdam, 1992

The beauty and the actor: ukiyo-e, exh. cat., Rijksmuseum, Amsterdam, and Rijksmuseum voor Volkenkunde, Leiden, 1995

L. Bickford, *Sumo and the woodblock print masters*, Tokyo, 1994

J. Bicknell, *Hiroshige in Tokyo: the floating world of Edo*, San Francisco, 1994

L. Binyon and J. J. O. Sexton, *Japanese colour prints*, London, 1923

K. J. Brandt, *Hosoda Eishi 1756-1829*, Stuttgart, 1977

T. Clark, *Ukiyo-e paintings in the British Museum*, London, 1992

T. Clark, *Fifty impressions: Japanese colour woodblock prints in the college art collections, University College, London*, London, 1993

T. Clark and O. Ueda, *The actor's image: printmakers of the Katsukawa school*, Chicago, 1994

R. A. Crighton, *The floating world: Japanese popular prints 1700-1900*, London, 1973

M. Forrer, *Hokusai*, London and Munich, 1991

M. Forrer, *The Baur collection, Geneva*, 2 vols, Geneva, 1994

M. Forrer (ed.), *Essays on Japanese art presented to Jack Hillier*, London, 1982

H. C. Gunsaulus, *The Clarence Buckingham collection of Japanese prints: the primitives*, 2 vols, Chicago, 1955

R. Hempel, *Ukiyo-e, Meisterwerke des japanischen Holzschnittes aus dem Kupferstich-Kabinett Dresden*, Dresden and New York, 1995

J. Hillier, *Suzuki Harunobu*, Philadelphia, 1970

J. Hillier, *Japanese prints and drawings from the Vever collection*, 3 vols, London, 1976

C. Hirano, *Kiyonaga: a study of his life and works*, Cambridge, 1939

S. Hughes, *Washi*, Tokyo, New York and San Francisco, 1978

Impressions: Japanese prints and paintings in the Utagawa tradition, exh. cat., The Museum of Decorative Art, Copenhagen, 1994

S. Izzard, *Kunisada's world*, New York, 1993

D. Jenkins (ed.), *The floating world revisited*, Honolulu, 1993

M. M. Kanada, *Color woodblock printmaking: the traditional method of ukiyo-e*, Tokyo, 1992

Katsushika Hokusai, exh. cat., Tobu Museum of Art, Tokyo, 1993

R. S. Keyes, *Japanese woodblock prints: a catalogue of the Mary A. Ainsworth collection*, Ohio, 1984

R. S. Keyes, *The male journey in Japanese prints*, Berkeley and Los Angeles, 1989

R. S. Keyes, *The art of surimono*, 2 vols, London, 1985

R. S. Keyes and K. Mizushima, *The theatrical world of Osaka prints*, Philadelphia, 1973

S. Kita, *A hidden treasure: Japanese prints from the Carnegie Museum of Art*, Pittsburgh, 1996

R. Lane, *Images from the floating world: the Japanese print*, Fribourg, 1978

R. Lane, *Hokusai: life and work*, London, 1989

H. A. Link, *Primitive ukiyo-e from the James A. Michener collection in the Honolulu Academy of Arts*, Honolulu, 1980

H. A. Link, *Prints by Utagawa Hiroshige in the James A. Michener collection*, 2 vols, Honolulu, 1991

J. Meech, *Rain and snow: the umbrella in Japanese art*, New York, 1993

P. Morse, *Hokusai: one hundred poets*, London, 1989

A. Newland and C. Uhlenbeck (eds), *Ukiyo-e to shin hanga: the art of Japanese woodblock prints*, New York, 1990

J. Pins, *The Jacob Pins collection of Japanese prints, paintings, and sculptures*, Jerusalem, 1994

C. van Rappard-Boon, *Catalogue of the collection of Japanese prints: Rijksprentenkabinet*, 5 vols, Amsterdam, 1977–90

L. P. Roberts, *A dictionary of Japanese artists*, New York, 1990

B. W. Robinson, *Kuniyoshi*, London, 1961

B. W. Robinson, *Kuniyoshi: the warrior-prints*, London, 1982

E. de Sabato Swinton, *In battle's light: woodblock prints of Japan's early modern wars*, Worcester, 1991

E. de Sabato Swinton, *The women of the pleasure quarter: Japanese paintings and prints of the floating world*, New York, 1996

T. Screech, *The Western scientific gaze and popular imagery in later Edo Japan*, Cambridge, 1996

C. Seigle, *Yoshiwara, the glittering world of the Japanese courtesan*, Honolulu, 1993

H. D. Smith II, *Hiroshige: one hundred famous views of Edo*, London 1986

L. Smith (ed.), *Ukiyoe: images of unknown Japan*, London, 1988

B. Stewart, *Subjects portrayed in Japanese colour-prints*, London, 1922

F. Succo, *Toyokuni und seine Zeit*, 2 vols, Munich, 1913–14

The theatrical prints of the Torii masters, exh. cat., Riccar Art Museum, Tokyo, 1977

S. E. Thompson and H. D. Harutoonian, *Undercurrents in the floating world: censorship and Japanese prints*, New York, 1991

Sharaku, exh. cat., Tobu Museum of Art, Tokyo, 1995

E. Tinios, *Mirror of the stage: the actor prints of Kunisada*, Leeds, 1996

Ukiyo-e shūka, vol. 11 (with commentaries on eleven of the Fitzwilliam's prints by Narazaki Muneshige and Yamaguchi Keisaburō), Tokyo, 1979

D. B. Waterhouse, *Harunobu and his age: the development of colour printing in Japan*, London, 1964

D. B. Waterhouse, *Images of eighteenth-century Japan*, Ontario, 1975

INDEX OF ARTISTS

ACKNOWLEDGEMENTS

Firstly I am grateful to Duncan Robinson and the Syndics of the Fitzwilliam Museum for granting me study leave to finish the text of this book, and to my colleagues David Scrase and Jane Munro for shouldering the burden of my absence. Among the many others at the Fitzwilliam Museum who have helped, I am particularly indebted to Andrew Morris for taking such care with the photographs, Sebastian Watt for his support and advice, Celia Withycombe for her essay and for her conservation of the prints, Fiona Brown, Bryan Clarke, Robin Crighton, Julie Dawson, Margaret Greeves, Marita Hambling, Ruth Hart, Lesley Nolan, Eleanor Smith, Thyrza Smith and Penny Wilson.

Outside the Fitzwilliam my thanks go to the designer Ray Carpenter, John Taylor, Lucy Myers and Charlotte Burri at Lund Humphries, and Paul Gumn at BAS Printers, for the parts they played in the production of the book. Others who have helped in various direct and indirect ways include Markus Bockmuehl, Sally Jeffery, Simon Jervis, Tadashi Kobayashi, Peter Kornicki and Hiroko McDermott.

Above all I would like to pay tribute to Timothy Clark, of the Department of Japanese Antiquities at the British Museum. Tim has been a continual source of illumination on the subject of *ukiyo-e*, both in conversation and in response to specific questions concerning the Fitzwilliam's prints over the last few years. He kindly read a preliminary draft of this book and suggested numerous improvements. Any remaining infelicities or inaccuracies are entirely my own.

Craig Hartley